Bio-Politicizing Cary Grant

Pressing Race, Class and Ethnicity into Service in "Amerika"

Bio-Politicizing Cary Grant

Pressing Race, Class and Ethnicity
into Service in "Amerika"

Joshua David Gonsalves

Winchester, UK
Washington, USA

First published by Zero Books, 2015
Zero Books is an imprint of John Hunt Publishing Ltd., Laurel House, Station Approach,
Alresford, Hants, SO24 9JH, UK
office1@jhpbooks.net
www.johnhuntpublishing.com
www.zero-books.net

For distributor details and how to order please visit the 'Ordering' section on our website.

Text copyright: Joshua David Gonsalves 2014

ISBN: 978 1 78279 771 5
Library of Congress Control Number: 2014945006

A CIP catalogue record for this book is available from the British Library.

Design: Lee Nash

Printed and bound by CPI Group (UK) Ltd, Croydon, CR0 4YY

We operate a distinctive and ethical publishing philosophy in all
areas of our business, from our global network of authors to
production and worldwide distribution.

CONTENTS

Foreword by Tom Cohen:
Pre-Carious Grant

"...decaying, never to be decayed..."

It has been a matter of time: that is, until the curious construct that is Cary Grant drew the semiotic imagination to cut deeper, or perhaps glide the surfaces that Hitchcock associated with him (since to a degree "Cary Grant" was, if not Hitchcock's invention, then Hitchcock's *Semiotik*, as Nietzsche says of Plato's "Socrates"). If we are drawn back to read Cary Grant differently today, it is because of this primarily: Hitchcock took Grant up, first, as a knowing citation of himself in *Suspicion*, then cited and turned that again and again in three further works. Then he was through. So we start with Joshua David Gonsalves at the end of that production line, at the point at which the hole that is Cary Grant is complete. He has become a star's star whose face is familiar and seductive, making women fall in love with it like an advertisement; yet his is also a face which, if you pass into it, is unreadable.

This unreadability is not the fulcrum of *Suspicion*; the undecidability of that too familiar and loveable face is socio-pathic, lie-generative (like Marnie later), murderous. Yet the film doesn't have to go there, for good reasons it holds back, hung in between, generating more folds at the "end," but placating stupid viewers about Grant's *brand* (definitely not a murderer, please, and then, not of women, and then, not of a gullible, naïve, generous, mousy, irritating Joan Fontaine with reading glasses). He cannot stop calling her "monkey face," always when his plastic face looks like a monkey itself, his ears propped. Grant is, for Hitchcock, a figure of defacement. This is not only because Hitchcock camera-claws him into becoming nothing but face: for instance, in *North by Northwest*'s quibbles about big faces and

finally Mount Rushmore's slippery ones. That, in the end, echoes too in George Kaplan, the non-existent hole in identity, a name which translates into "Head of the Earth." If one pursues the enigma of Cary Grant as industrial product, it leads through the entire era of cinema (which for Bernard Stiegler begins with cave paintings and ends today). It passes through the organization of how we identify with faces, grant them credit, credence or identification. Hitchcock knew heads and faces—enough not to give them credit for being what they seem or where they claim to be. Face, Hitchcock said to Truffaut, doesn't exist, it never emerges from the shadings of light that suggest its possibility. *Prosopopeia* never arrives and Mount Rushmore stares it down, looking across the American continent.

One has to return to the opening of *North by Northwest*, since the fact that Thornhill-Grant is an advertising executive links him to the media product marketed and sold as "Cary Grant." Like his dictation to his amanuensis in the cab (make a note, remind me to "think thin"—which the film then proceeds to do), and like cinema, the idea of Cary Grant is circular; the product that precedes the original that copies it. Grant spoke of "Cary Grant" in the third person, as an artifact he inhabited. His private life never quite meshed with the artifact's, but the LSD was a nice touch (to fight homosexual tendencies)—and, given his legitimate options for narcissism, that wasn't an issue for Hitchcock's cipher. Like Grace Kelly—and unlike many actors and actresses who would simply be run through the mill, tormented as needed, let go without knowing what was up— Grant seemed in on it. Not intellectually or knowingly, but because he was that good. He was the acrobat first, the protégé of Mae West and, for Hitchcock, a dead-zone cipher; he was the perfect zero or Ø, much better than James Stewart who seemed to like being defaced and emasculated. That is why *North by Northwest* opens with Grant stepping out of the elevator on the ground floor (on which Gonsalves comments). Cary Grant has

left, in other words, Jimmy Stewart's Scottie on the roof at the end of *Vertigo*, the preceding film. None of that psycho formalism here, nor anything like *faux* Wagnerism for the too worldly and too ambiguous Grant. Besides, he serves different algorithms: horizontal ones in lieu of vertical ones; ones running off the map (literally).

It is not accidental that George Kaplan's hotel room is in the Plaza, where Grant kept an apartment. Hitchcock has Thornhill go to Cary Grant's apartment, where there are nothing but fake traces. But this goes on, since where Grant leads Hitchcock, and vice versa, is to a defacement—not only of the actor Grant, whose skills are mocked by the Shakespearean James Mason, but of the earth through him. Grant is the last "superstar" product to hold Hitchcock's screen. Later the stars will be birds.

This practice will recur. In *Notorious*, Grant is taken down— yet, surprise, it is the closest thing to a happy ending in Hitchcock's films. Yet in *To Catch a Thief*, Hitchcock cites and dismantles "Grant" as jewel thief, his face stealing trust and identification, a walking copy chasing a "copycat" of himself ("the cat"). Don't get *carried* away, says Kelly, inserting his unreal "real" name into the *mise-en-scène*, and his putative origin as a screen actor is cited in badinage: he was with a "travelling circus that folded." Theft in this film is pre-originary, as of fire by Prometheus, or of the photographic shot. Even the sun is a technic, as exemplified by the pyrotechnics at Cannes. Grant's sexual ambiguity ricochets about as references to "the boys" lead to an unmasking of his copycat, the original fake catching the copy it gave rise to against itself—and it's a "teenage French girl" in disguise.

It's about time, whines Kelly—"time" being the most used word in the work. If an original copy chases his copy, what comes first: the chicken or the egg, both of which crisscross the screen as if to materialize the problem of cinema? When tooling about in a motorboat, we see that its name is mockingly "Marquee Mouse."

The vessel puts Grant in what marks the origin of cinema in animation, cartoons, graphics. Every "origin" Grant encounters is technically cancelled. Even Mrs. Stevens's diamonds are there because of oil discovered near her then-outhouse—where her husband, Jeremiah, a conman, never knew how close he was to millions. Diamonds enable the refracted surface of the cinematic to return to carbon, *bijoux* all the way back to oil, which yields the light that projectors cast.

It's about time to Bio-Politicize Cary Grant. Specifically, time that this American cipher is engaged, tracked and, above all, deciphered anew.

Preface:
"We're all living in Amerika"

"We're all living in Amerika
Coca-Cola, sometimes war
We're all living in Amerika"

This is not only a book about Cary Grant, nor is it simply about class, race and ethnicity in the United States of America. If "Amerika" is that everywhere-nowhere eviscerated by Rammstein in their song "Amerika" (2004), I hope to outflank this defense-formation here and once more in a book to come: *Bio-Politicizing* Nymphomaniac: *Lars von Trier in the Shadow of Tarkovsky and David Lynch*. In the meantime, *Bio-Politicizing Cary Grant* follows the trail left by the actor-star's iconic trajectory through a study of Hitchcock's preoccupations. The cinematic icon is not equivalent to the theological afterimage known as the "ikon," but I defer that problematic to an analysis of Tarkovsky's influence on von Trier.

Bio-Politicizing Cary Grant analyzes how American, Americanized and Anglophilic audiences have always looked at Grant so as to look away from other things. If Anglophilia functions as a way of unseeing being-American/ized, it also defers things that take too much time to think about. This book focuses, in contrast, on temporal vanishing points that stretch away into infinity leaving behind what William Blake calls a "slimy little substance." If this post-human residue seems, at times, to tower over us as a "Polypus of Death," or a Vampire Squid engulfing everything (*Jerusalem*, Plate 49; in *Complete Poetry and Prose*, 198), we do not lack names for this post-human submersion of subjective agency. We might call it the *longue durée* of a 5000-year-old world system alongside a techno-automated apparatus of everyday wartime, in which we are button-pushers

situated in an irreversible genealogy of total war. Alternatively, we can dub it our mediatized capture by visceral media-feedback loops and administered-monitored perceptions. Thirdly, we now occupy an Anthropocene era in which humans are embedded by our capacities as a terraforming force that we cannot recognize as our own. And, finally, there is the Lacanian unconscious re-elaborated by Badiou's post-human summa of our disappearance from our own anthropo-scene. So many ways of unseeing the military-historical real or what upholds this unseeing: the irrealization of the mediated by multimedia mobile devices. So many ways of substituting the identity-forming nexus of family, nation and bio-political benev(i)olence for encounters with the extinction of matter in motion or inhuman truth procedures. I prefer to maintain a trace of the real in lieu of encircling Hitchcock and Grant in the ludic, the reflexive or an aesthetic of the merely fictional.

Cary Grant focalizes, then, a moment in this fourfold genealogical process. We share this moment where race, ethnicity and class are "names" for a sustained unseeing of shadowy forces. If these inconsistent (socio-economic and geo-political) multiplicities are inoculated by the holistic foods of identity politics, imaginary advocacies and restricted media-feeds, this stance can also be reformulated in an alienating formula: ArabSpringBreakers of the World Unite! Enter, in lieu of this, a world where we have never stopped being displaced from ourselves: please leave all prejudices at the door, as if they were shoes, and this book a Japanese *dasha*. Hai!

Acknowledgments

Thanks to Rainer J. Hanshe at *The Nietzsche Circle*, where I first published on Hitchcock via a review of Tom Cohen's *Hitchcock's Cryptonomies*; to all involved in *The Birds Now* conference (2010), including Susan Lurie and Tom; to all the Beiruti cinephiles among whom this book got hammered out; and to the crowds at *Ikonokino*, *Chico's* and *Dawawine*. Thanks as well to my students in *Race in "America": Post-Racial Cinematics* at the American University of Beirut (as well as to the masses populating my introduction to Cinema Studies, *Film as Text*), who suffered through versions of this text (especially Yasmina), and to the under/graduate assistants who helped prep the text for *poubelli-cation* (Mariam/Sarah). Lastly, ultimate gratitude to Cyberia, an ultra-fidelious immortal disguised as a dog.

Bio-Politicizing Cary Grant: Pressing Race, Class and Ethnicity into Service in "Amerika"

"LORD, how are they increased that trouble me! many are they that rise up against me."
Psalm 3, King James Bible

The diegetic action of *North by Northwest* (1959) begins in the bustling core of midtown Manhattan. Crowds of various classes exit office buildings as they rush home from work. The on-location shots teem with New York City area residents of diverse races and ethnicities.[1] This diversity is, however, held in check by class, a status connoted by the Gray Flannel Suit signifying conformity to capitalism in Sloan Wilson's 1955 novel *The Man in the Gray Flannel Suit*.[2] Cary Grant appears out of an elevator wearing a top-shelf version of this armor that indelibly marks him as a professional-managerial upper-class master of the white-collar class in the narrative, while also reflecting his star power as a Hollywood apotheosis of class incarnate.

This sense of Grant belonging to "a class apart," or beyond the middle and upper classes that consume this image of "class," identifies him within an exclusive social geography only available to the superrich on the Riviera and other luxury spots where Hitchcock liked to vacation.[3] Yet before the superstar emerges we see a non-descript man in a generic gray suit pop out of the elevator, suggesting the interchangeability of this class difference between the upper and middle classes. This indeterminacy is central to the film, for Grant's character (Roger O. Thornhill) will soon be mistaken for the non-existent secret agent George Kaplan, created by the United States Intelligence Agency. The non-existent Kaplan has been painstakingly produced by this bio-political Agency to decoy the villain of the film Phillip

Vandamm (British actor James Mason) away from their real agent Eve Kendell (played by American superblonde Eva Marie Saint), and the Agency is more than happy to let Thornhill take the fall to protect the far sexier Eve. Grant's character is, as a result, profiled as a *persona non grata* by the authorities and pursued by the police for a crime he did not commit. This instability of identity is characteristic of America in the fifties insofar as it imagined itself to be threatened by homosexuality and communism within the heartland (see Corber), as well as by the worldwide underclass unrest communicated by Cold War fears of class and race war in Hitchcock's paranoiac *The Birds* (1963). I propose to extend this state of siege by focusing on how race and ethnicity—including the ambiguous Anglo-American or transatlantic Hollywood ethnicities of Grant, Hitchcock and, to a lesser extent, Mason—complicate class dynamics in the film. I begin by drawing attention to the internal aliens populating the generic midtown crowd.

Chapter 1

The Uncr(edited) Crowd

Before *North by Northwest*'s uncredited and largely unedited crowd surges onto the screen the credits are seen. The *générique*, designed by Saul Bass, begins with horizontal and vertical lines crisscrossing a green-colored screen. These lines invite reading as a tracking grid reflecting a desire for total state surveillance of the mapped territory, a territory that Hitchcock's film, cast and crew traverse from the East to the West Coast. It is within this grid that Cary Grant will be mapped and trapped. As the credits end the pattern gives way to the mirrored International Style façade of the CIT building designed by Wallace K. Harrison, who also collaborated on the UN building complex that appears later in the film (see Jacobs 299). As the real-time image appears we see people, taxis, cars, street and sidewalk reflected in this architectural monument to High Modernism. In the right hand corner, a fragment of the real street scene is visible. Yet as the diegetic Manhattan setting is superimposed on the generic grid, a slight difference between the real-time image and the abstract image is noticeable: the building curves slightly in comparison to the geometrically consistent grid image. This dissonance introduces the anxiety that fifties-era America cannot be captured, fully monitored or represented either by the state, or by the abstract "spatial system sequence of the film" (Jameson 55) that Hitchcock creates via "means of locomotion," including highly racialized buses and trains (Bellour 108).

This anxiety over abstraction forces a common criticism of the International Style to the fore—namely, that Modernist architecture is indifferent to the masses. This accusation will be reiterated in the film by the UN Headquarters, partially designed by Le Corbusier, whose disastrous city-planning for the teeming

3

Indian masses of Chandigarh compounds this critique of architectural Modernism beyond repair. The United Nations is also an apparently multi-ethnic site of equality protected by international law, yet only, according to the film, on the condition that every man wears a Western suit. I will return to this interracial extraterritoriality, exploring its implicit criticism of fifties-era America as an insulated space reserved for white consumers of middle- and upper-class culture.

To return to midtown: Hitchcock hated shooting on location. His aesthetic bent was to create a self-enclosed world on sound stages where he could control lighting, actors, extras, production design, etc. and prevent contingency from interrupting either the shooting schedule or his stylistic vision. Actually shooting a film usually bored the director. For *North by Northwest*, however, he enjoyed on-location shooting in New York and Chicago, as well as in South Dakota—site of the grand finale on Mount Rushmore—and near Bakersfield, California—the backdrop for the famous set piece, "attempted murder by crop-duster plane." On-location shooting elicits the ethnically mixed crowd in the opening sequence, a contingency that the director could not absolutely control (unlike his decisions with regard to which races received speaking parts or prop weapons). This contingent event solicits reading alongside other moments of race and ethnicity staged by Hitchcock and his collaborators, the production staff and film crew. A reading of the oblique presence of race and ethnicity in this opening sequence will set the stage for the rest of my analysis by allowing me to anticipate how this presence informs *North by Northwest*.

Everybody seems to be speeding along in this sequence. It is rush hour. No one stops moving as diverse classes, races and ethnicities mingle and jostle in their struggle to get home. A dissonant moment in this tumult is the lack of movement exhibited by two African-American women as they hesitate in front of an office building entrance. They seem strangely ill at

ease, paralyzed and overly deferential to the confident prece-
dence claimed by the white-collar crowd. The women do not
move with the same fluidity as those surrounding them. Their
clothes mark them as less than secretaries and it is as if they are
aware of their second-class status in the racial-social geography
produced by the spatial system of *North by Northwest*. Only one
African-American man is given a speaking part in Hitchcock's
film; he is not individualized and is addressed as "Porter" by
Eve Kendall (Thornhill's love interest and a double agent serving
the United States Intelligence Agency by posing as Vandamm's
mistress). The rest of the African-American extras in the film are
limited to a variety of demeaning postures: 1) blue-collar roles
such as Red Caps or baggage carriers in the New York (and
possibly the Chicago) train stations; 2) waiters and bartenders
(but not the maitre d') on the exclusive train from New York to
Chicago; 3) a hotel valet and possibly a doorman at the
Ambassador East Hotel in the Windy City (but not in the Plaza,
Cary Grant's home-away-from-home in real life Manhattan,
where he had a suite reserved for his use); 4) security guards at
the art auction. They never appear as cab drivers or armed
policemen, many of whom have speaking parts. Before getting to
these various African-American and ethnic hordes (the security
guards, for example, are indeterminately raced yet clearly not
white and, unlike the white policemen, are obviously too
unreliable to be allowed to carry firearms), I wish to return to the
two displaced women.

In the penultimate shot of the opening crowd sequence, the
same office building entrance in front of which the women were
momentarily motionless reappears, except now there is a
noticeable gap marking their absence. Bernard Herrmann's
fandango score approaches climax, stressing the emptiness of the
space and whisking away the ethnic strife in fifties-era New York
referenced by *West Side Story* (staged 1957-9; dir. Robert Wise
and Jerome Robbins, USA, 1961), which also featured "South

American rhythms and a 6/8 fandango" (Daniel-Richard 55).[4] The crowd around their absent presence is now less hostile, less dense and more homogeneous (read: white). I could perhaps be suspected of over-reading the film's opening sequence even if one grants that the elided, encrypted or stereotypical presence of race and ethnicity in fifties-era American film requires a symptomatic style of reading. Significantly, however, the previous shot shows Hitchcock rushing to get a bus only to find it shut in his face; at that exact moment we see an African-American man in a suit calmly going about his business behind him. There are, incidentally, at least two almost unnoticeable African-American men in suits in the New York and Chicago crowds. Since public transport was a site for racial segregation, discrimination and Civil Rights reform (i.e. the Montgomery Bus Boycott in 1955) a curious equation begins to take shape.

The rise of race mobility and the suit as a sign of passing as normal, middle-class or "white" both situate Hitchcock in the place of the other in this scene, a fall from grace that Cary Grant's character experiences throughout the film and that the film's crowd-pleasing conclusion will attempt to resolve *con brio*. Hitchcock's cameo could be explained away as an example of his infamously "off-color" or "black" humor, yet these loaded metaphors for Hitchcockian jokes foreground race once again. Any resolution of race anxiety is, as we will see, undercut by what many critics regard as Grant's ultimate lack of ground as a star.[5] Grant, in embodying this groundlessness in *North by Northwest*, ends up falling away from self-assured racial, ethnic, classist and nationalist identities.

I can already hear the Anglophilic rejoinder: "A class-conscious Englishman like Hitchcock"—who became a dual American citizen in 1956—"would never be caught dead mixing with ethnics on a public bus!" This knee-jerk reaction is complicated by Hitchcock's cameo in *To Catch a Thief* (1955), which places him in the back seat of a bus next to Grant. Cary Grant, a

British citizen who became an American in 1942, lends credence, however, to the classist and racialist rejoinder when his character later exasperatedly informs a teller that he cannot possibly go coach from New York to Chicago on the prestigious Twentieth Century Limited: "No, I can't do that." Roger O. Thornhill cannot do so because he could be more easily caught by the law in coach, yet the viewer cannot help but hear the sublimely snobbish voice of Cary Grant here. This voice is persuasively supplemented by Grant's star persona, since his contract for *To Catch a Thief* stipulated, among other extravagances, "an air-conditioned limousine—either Lincoln or Cadillac—with liveried chauffeur, specially ordered from England and delivered to France" (McGilligan 498).

Hitchcock and Grant ultimately expose the Anglophilic rejoinder as reactionary. This exposure is all but unavoidable, since they are both stage, performative or Hollywood Englishmen. Hitchcock occupies this role due to the fact that he loved to play the wry "we-are-not-amused" upper-crust English gentleman in the introductions to *Alfred Hitchcock Presents* (1955-62) and *The Alfred Hitchcock Hour* (1962-5). He also hammed up this crowd-pleasing persona in his trailers in the fifties and sixties, a role he could not play as successfully in his homeland due to his lower-middle-class and Catholic background. If this class analysis seems too pat, Hitchcock evidently preferred to live, like Grant, in America. Grant, who also came from the lower-middle classes, worked his way through the circus, vaude-ville and the Broadway stage, rising to fame as a Hollywood incarnation of Englishness who also claimed America as his homeland (take his ostentatious publicizing of himself as a fan of baseball, for instance). Grant's hybrid identity is exemplified by his notoriously ambiguous, transatlantic or international playboy accent and persona (a "Lincoln or Cadillac—with liveried chauffeur, specially ordered from England"!). This persona is in full flower in Hitchcock's *To Catch a Thief*, in which

Grant plays an expatriate American living it up in Nice, Cannes, Monte Carlo, Monaco, etc.

Grant, like his latter day imitator George Hamilton, seems too Mediterraneanized to be white in an American sense, too tanned and debonair in comparison with the charmingly awkward and all-American Jimmy Stewart, Hitchcock's other leading man of choice in the forties and fifties (*Rope*, 1948; *Rear Window*, 1954; *The Man Who Knew Too Much*, 1956; and *Vertigo*, 1958). Stewart, in fact, expected and wanted to play Roger Thornhill, and Hitchcock had to "diplomatically" defer answering Stewart until the actor finally signed on for another film, freeing the director to cast his first choice: Cary Grant, his ambiguous class double and co-conspirator in performing an ethnicized Englishness (Eliot 480). Grant's performances of race and ethnicity remain, then, indeterminate in the extreme. Grant is akin to Hamlet in the Shakespeare play, a key if critically contested intertext in the film. This kinship enables him to shine forth in *To Catch a Thief* and *North by Northwest* (and not in the black-and-white films *Suspicion*, 1941; and *Notorious*, 1946) as someone who has been "too much in the sun" (*Hamlet* 1.2.67).

Richard Dyer argues that tanning reaffirms white "prestige" by being a reversible choice available only to whites (49). This is clearly the case; yet imagine a horror film entitled *The Tan That Wouldn't Go Away*, an apt designation for Grant's perpetually deep tan that echoes the bisexualized ambiguity signified by the comic-horror title of the Grant-Howard Hawks collaboration *I Was a Male War Bride* (USA, 1949). Grant's unreal tan communicates, in other words, an anxiety about the slippages away from stability at the basis of racial, ethnic and sexual privileges. So too, there is something stereotypically fey, idle or indolent about being so impossibly tanned all the time. The actor, in any case, connotes both whiteness as "unattainable" and a "slippage" away from this "impossible" position, a slippage that downgrades "ordinary whiteness" as a class apart from the

fantasy of being a superrich white (or non-white) star (Dyer 78, 62). The color line was being crossed by non-white stars in the late fifties; for example, by Sammy Davis Jr, who would have married the superblonde Kim Novak if Harry Cohn, the Mussolini-worshiping boss of Columbia, hadn't threatened his life and forced him to pass as black by marrying an African-American chorus girl (see Kashner 196-216). Rumor has it that the downgrading of Cohn's replacement for Rita Hayworth, the "valuable commodity" Kim Novak, by her interracial liaison with Sammy David Jr provoked a fatal heart attack when the mogul received a "packet of press clippings called 'Kim and HIM'" (211, 197).

The ethnic and racial category of whiteness seems, in sum, self-evident in fifties-era America, yet it is continually under siege in *North by Northwest*. The abjection conveyed by the bus in the *générique* returns later in the film when Cary Grant takes a Greyhound from Chicago to the cornfield where he narrowly evades death. Can this bus ride be read as a parodic under-cutting of his Gray Suit in tandem with the gray poodle on a leash that parades into the frame alongside Grant in the lobby of Chicago's Ambassador East?[6] Hitchcock, we recall, can't even get on the bus in the opening sequence. If whiteness is threatened by race mobility, or by others passing as *The Man in the Gray Flannel Suit*,[7] fifties-era America also insists on imagining a space free from race anxiety, doubling and parody where the other can be safely contained as a service person.

To return to the displaced African-American women: this imaginary of a race-free space is, then, what is established by the office building entrance being purged of blackness or, at the very least, of the awkward sight of a subaltern who doesn't or can't quite fit in. This is the isolated space that Cary Grant has existed in up until the day when he is mistaken for another, abducted and converted into an outlaw: call him Roger Thornhill or George Kaplan. This white space is fused with the carefree

identity of a Manhattan advertising executive at home in the Plaza's Oak Bar, 21, The Winter Garden Theater and other locations of symbolic capital, and recurs over and over again in the film. It reappears, for instance, via the variegated consumer locales where racialized service people cater to the shared desire of the middle and upper classes for attaining cultural distinction through the exercise of taste: the swanky train dining car, the elegant hotels, the art auction and the kitschy pleasures of Mount Rushmore's tourist café. The fact that the upper classes frequent the same locations as an aspiring middle class mass reminds us that slumming is a class privilege for the former (akin to tanning as an exclusionary racial practice reserved for those marked as white). It is therefore to the disavowed workers empowering these insular spaces that I now turn, since these "invisible workers" are decisively marked as non-white by being denied any semblance of a menacing racial mobility.

Chapter 2

Invisible Workers

Since the parameters of this analysis may seem far-fetched, I pause to relate my concerns to the conjuncture presently existing between Hitchcock's films and Hitchcock criticism. *Murder!* (1930) is, alongside *The Lodger* (1927) and *Blackmail* (1929), one of Hitchcock's first signature films. In *Murder!* the villain is a "half-caste" named Handel Fane. His "black blood!" (Herbert Marshall's character's exclamation when he learns of this scandalous hybridity) motivates the narrative, for he murders his victim to prevent her from revealing his dark secret to his beloved yet racist wife-to-be. In *Young and Innocent* (1938), the murderer is also raced, except this time he attempts to evade capture by minstrelizing himself in blackface in order to pass as a jazz drummer. His attempt fails, and he is finally exposed by an elaborate crane shot that zeroes in on his identifying trait: twitching eyes.

A glance at *Murder!* establishes that race serves as a pretext for paranoia in regard to an interloper imperceptibly passing as white. The dandyish Fane initially appears wholly English, but his biraciality is soon criminalized as the motivating cause of the murder that he has committed. *Young and Innocent* extends this paranoia by placing this alleged moral blackness within. Race is not what exposes the murderer, but his twitching eyes, yet the gratuitous use of blackface is not integral to the plot and suggests an anxiety reiterated in *North by Northwest*: the danger-ously performative groundlessness of race mobility, as is marked by Fane's passing as white and by the white murderer's almost unnoticeable minstrelization as a black jazzman (black = jazz, according to the cliché at work). In the latter case, it might be argued that racial difference is reaffirmed by a white man

passing as black insofar as it is a privilege based on prohibiting the reverse. However, like the carcinogenic practice of tanning and the urban myth of a white journalist, John Howard Griffin, who supposedly died by medically blackfacing himself in order to expose racial prejudice in his book *Black Like Me* (1961), the reversibility of race remains dangerous if not literally deadly. To complete the *North by Northwest* parallel, the protagonist in *Young and Innocent* is also accused of a murder he did not commit. So too, he escapes police surveillance thanks to a generic suit supplemented by eyeglasses that hide his inner criminality from the profiling eyes of the law and its power to decide who is (and who is not) morally blackened.

In the second version of *The Man Who Knew Too Much*, race returns in the form of the Moroccan crowds that are more than a quaint background for an all-American family (Jimmy Stewart and Doris Day!) on vacation in the Mediterranean. Tom Cohen notes how the shadowy presence of "impoverished sweatshop" labor haunts the vacationers with "the destitution of Moroccan poverty," specifically with "rows of identical," "faceless" "women" extras (1. 208, 215). Cohen then ties in these effaced producers of consumer products to the effaced workers to whom Thornhill's mother assigns the maintenance of George Kaplan's haberdashery: "Maybe," as she says, "he has his suits mended by invisible weavers" (1. 215). To privileged men like Thornhill, as mother knows best, the labor of strangers is as invisible as the unnoted presence of racialized laborers, security personnel and service persons in *North by Northwest*. The film emerges, ultimately, as an American space in which the "colonial labor and service" externalized and consumed as exotic in the alien geography of *The Man Who Knew Too Much* return to harass agencies of homeland security (1. 214).

In *Topaz* (1969), a black character finally contributes a substantial speaking part to a Hitchcock film—to wit, one that propels the narrative forward in the interests of national security.

Roscoe Lee Browne plays a West-Indian florist doubling as a secret agent against the Cold War enemy. In his Cold War films, *Topaz* and *Torn Curtain* (1966), however, Hitchcock's will to aestheticize geo-political realities fails.[8] *Marnie* (1964) is possibly the last signature Hitchcock film, although he returns to stylistic form in a virtual remake of *The Lodger*, entitled *Frenzy* (1972), and less effectively in the extended *jeu d'esprit*, *The Family Plot* (written by *North by Northwest* and *West Side Story* screenwriter, Ernest Lehman; 1976). *Frenzy* and *The Family Plot* could, however, have been set in a pre-Cold War world while *Topaz* and *Torn Curtain* register the Cold War by setting scenes in Cuba and East Germany, respectively. This engagement with contemporary politics proves inimical, however, to the director's aesthetic tendency to create self-enclosed worlds apart from geo-political realities. A possible reason for the success of *North by Northwest* is that Lehman's light and witty touch prevents politics from spoiling Hitchcock's aestheticism. This aestheticization cannot avoid registering, in the meantime, socio-political problems internal to America thanks to the overwhelming presence of race and ethnicity in the film once the viewer is alert to their encrypted articulation.

I will now substantiate my schematized sketch of this estranging presence by tracing Cary Grant's attempts to remain white: to retain privilege, power and prestige. Three points of reference seem essential to tracking the interaction between race, ethnicity and class in *North by Northwest*: 1) the scene where Grant passes as a Red Cap or railway station porter (a role filled by African-Americans for the most part at Penn Station and by other ethnicities in Chicago's Union Station) in order to escape the policemen and detectives monitoring the passengers disembarking from the Twentieth Century Limited; 2) the scene where Grant returns from almost being killed in a cornfield only to have Eva Marie Saint tell him that his dusty, crumpled suit makes him look like a blood-bespattered worker

in the Chicago "stockyards"; 3) the final scene where Grant proposes to Saint as the Twentieth Century Limited roars into a tunnel in an explicit coupling of anarchic, insensate sexual intercourse (*jouissance*) and social legitimation, marriage and a return to the capital of the Northeast, New York City, via a Northwest detour.

The Red Cap scene foregrounds worker unrest (the headline "2 uprisings" is decipherable in a newspaper read by a United States Intelligence Agency manager), as is emphasized by the instant profiling of red-capped workers by operatives of the bio-political state when they search for Cary Grant disguised as a Red Cap. If bio-political surveillance is formally underlined by a montage of invasive close-ups, the film's reference to the stockyards provides a genealogy for bio-political control insofar as the organizational logistics involved in the transporting, killing and processing of animals for meat in the Chicago Stockyards served as a model for industrial capitalism and bio-political militarism. Lastly, I mean to query the closure offered by the third scene in relation to the capitalist, (post-)industrial and bio-political processing of bare life constitutive of fifties-era America. Since Cary Grant was on his sixth wife when he died, and Thornhill ends the film by making Eve his third wife, this third scene will allow me to reexamine Stanley Cavell's argument that *North by Northwest* is a comedy of remarriage, or a not-unhappy reading of divorce. For Cavell, the ultimate problem that the film proposes to solve is one of remarriage. "America" emerges as a fictional space where this philosophical problem can be resolved, yet if this problem remains burdened by class, ethnicity and race, the weight that the conclusion of the film means to carry must be redistributed accordingly. I will offer a fresh assessment of the closure communicated by Hitchcock's masterful film. We will then be in a position to reassess his formalist achievement in light of the disturbance introduced into the conclusion by my reconsideration of two things: the previous Hitchcock film Grant

starred in—*To Catch a Thief*—and the high-angle shots that Hitchcock uses in his attempt to establish mastery over the matter of Cary Grant.

Chapter 3

"I'm an advertising executive, not a red herring"

North by Northwest begins with a tumultuous polycultural diversity that the film resists by figuring a space where race can be banished, contained and pressed into service. Cary Grant's character fits effortlessly into this world as he relies on his secretary, a gray-uniformed elevator attendant and a cabbie to get him to the Oak Bar, his prelude to an evening at the theater. The actress who plays Grant's secretary registers the race- and class-basis of this privilege by reappearing in *The Birds* as a mother who accuses superrich socialite Tippi Hendren of being the cause of the "bird war" that stands in for threats of a race or class war: "It's a uprising," as Tippi chirps in a scene that was shot and then cut from the final version, and "a peasant sparrow" or "a malcontent" is to blame. "With a beard," her co-star, Rod Taylor, pipes in, as if a joke could banish the anxiety at work. "Yes, of course, he *had* to have a beard," she replies, "'Birds of the world, unite,' he kept saying over and over..."

There are no racially or ethnically distinct service people at the Plaza Hotel, as if to preempt this infinitely repeatable anxiety of a race or class uprising. Race resurfaces in the Plaza when Grant needs to send a telegram to his mother and blithely refers to the blond bellhop as "boy," a residually racist term for invisible servants, in order to do so. Cary Grant is habituated to being serviced and it is this complacent action that leads him to be mistaken for George Kaplan (who the killers have paged at the same inopportune moment), a mistake that initiates his slippage away from his race-free comfort zone.

When Grant arrives at the Long Island estate of UN representative Lester Townsend that James Mason's villain (Vandamm)

has commandeered, there are again no racial or ethnic subalterns in sight. Townsend's estate is dressed up as a race-free zone where Mason—who appears as a cultured, poised Englishman, European or cosmopolitan in contrast to Grant's perpetual identity crisis as a hybrid British-cum-American citizen in Hollywood—treats his subordinates with a politesse and respect reminiscent of feudal paternalism. Yet this zone is anachronistic, as is underlined by Townsend's encrypted name, Town's End. We could read into this name the end of any nostalgia for *Our Town* (1938), a popular play written by Thornton Wilder, Hitchcock's co-conspirator in transforming Santa Rosa, California, into an idyllic small (read: white) town in *Shadow of a Doubt* (1943). Since the Russian delegation at the time was based, according to Ernest Lehman, in a Long Island property, the mansion is rendered even more suspicious.[9] Race is immediately revealed both as a performative construct dependent on class rather than complexion ("boy") and as an unreadable mask: the race-free Long Island manor epitomizes a superrich American estate modeled on Old World nostalgia, yet it serves as a cover for foreign agents. Grant is, after all, hoodwinked by Mason's performance and confronts the real Townsend at the UN. This blunder has serious consequences, since it causes him to become an apparent murderer on the run when Vandamm's henchman kills the man from UNIPO and leaves Grant holding the knife.

Returning to Long Island, Grant is soon forcibly intoxicated with bourbon, packed into a Mercedes and pushed towards a fatal cliff. He escapes, of course, and is incarcerated in an all-white police station. Returning to the Plaza, he interrogates two obligingly white service persons and, after escaping his assassins once more, takes a taxi to the UN to confront Townsend. At the UN he speaks to a soft-voiced South-Asian woman and heads to the lounge where diplomats of various ethnicities will become an audience for his framed performance as a murderer. The UN is an extraterritorial zone on the Eastern edge of Manhattan Island

apart from the class-structured rac(ial)ism of the city. All the men, however, are clad in Western business suits. The suit is spotlighted, in short, as what allows diverse individuals to join the so-called conversation of Western culture, geo-politics and international law aka the Cold War. The appearance of an "Indian" woman in a sari in the UN lounge is also stressed in contradistinction to the normatively dressed and charmingly accented South-Asian woman previously encountered by Grant as an exception that proves the rule. Yet the real murderer, Vandamm's agent, also uses a business suit to bypass security and kill the real Townsend. The danger posed by sartorial performativity, mobility and masquerade is consolidated. Invisible others are an omnipresent danger.

This threat is complicated by the integrative function of the UN as a space where one must be either American or anti-American during the Cold War, an either/or option that was being contested in the fifties by the Non-Aligned movement linked to the Bandung Conference in 1955. As Grant and Townsend talk, a delegation of African or West-Indian men in suits are being photographed exactly between them. The image of the flash is located in Townsend's back—that is, where the knife will soon penetrate him, reminding the viewer of the connection between cameras and weapons, shots and shooting. The men are seemingly recording their entry into the Western conversation symbolized by the UN. Yet this entry paradoxically makes their nations and the populations they represent into potential targets on the geo-political grid of Cold War international relations.

Grant flees to Penn Station en route to Chicago, yet his suit is no longer the cover it is for either enemies of the state or internal aliens. Grant's slip from sartorial untouchability is referenced by his realization of his vulnerability in the Penn Station crowd as well as by his comic attempt to compensate for this situation by donning "cheaters," as sharp-eyed newsmen call Grant's

sunglasses in Frank Capra's film, *Arsenic and Old Lace* (1944). As if anyone would fail to recognize Cary Grant in shades! On the other hand, his outfit, executive look and appearance of whiteness all help to keep him one step ahead of the law, as is seen both by his insistence on shaving in Union Station and by the fact that he has his besieged suit sponged and pressed by invisible workers in Chicago. Is it significant that this time the hotel valet is a mute African-American extra? Is Chicago's Ambassador East less race-free than Grant's home-away-from-home at the Plaza? Is this racial difference an index of how far Grant has fallen away from his insular Manhattan zone?

Race is registered on the way to Chicago by African-American service persons, who are distinguished in turn from their putative betters: the maitre d' and the Pullman conductors, as well as the "state police" who invade the train in their search for Grant. Grant is helped by superblonde Eva Marie Saint, a double agent for America and Vandamm's mistress, whose role is to seduce Grant and send him to his death at the hands of her foreign master so as to protect her secret identity. Eva Cherniavsky stresses how racial others help sublimate the über-whiteness of a certain kind of female screen star (71-99). This kitschy sublimation is typified by Marlene Dietrich's emergence from a gorilla suit—a grotesque King-Kong-ish stereotype of African-Americana—surrounded by "tribal" dancers in blackface, and supplemented by the inarticulate or not quite human stutter of the African-American bartender in the significantly titled *Blonde Venus* (dir. von Sternberg, USA, 1932). The title of Jo Sternberg's movie is significant in that it implies an antithesis to the "Venus Hottentot," a racially abjected stereotype of the African woman's corporeal difference that was wildly popular in the nineteenth century (Cherniavsky 93). Tom Cohen fleshes out Eva's sexy saintliness as a sublimated blonde by referring to Doris Day, Jimmy Stewart's wife in *The Man Who Knew Too Much*, as an "antiblonde" (1. 224), a role she occupies as

a "racing result" of her ineffaceable association with middle-class America, suburbia and domesticity alongside a concomitant absence of (hetero)sexual aura. Eva Marie Saint and Grant shine forth as Hollywood incarnations of the superrich, or a class above class that distributes distinctions below this unapproachable apex into suburban pseudo-towns. *North by Northwest* underlines, in sum, how both figures depend on their difference from other ethnicities and classes, including the "antiblond" young man Grant condescendingly calls "boy" in the Plaza.

Grant ends up in the superblonde's cabin, where she locks him in the upper berth in an effort to hide him from the police. "I stole [the] can opener [from] the porter," Saint confesses, a criminal act unnoticed by the worker in question, who quickly appears in the only speaking role assigned to an African-American character in the film. "Yes ma'am," he states, "I've been looking all over for it," perfectly fulfilling his submissive function as an Old-World-style servant oblivious to the improprieties of his betters. Grant hides in the bathroom while the porter tidies up the sleeping car, debasing his star status through association with the abject spaces where service people are invisibly placed. He discovers Eve's tiny razor in this cramped space (would it be too much to relate his being "packed" in a sleeping berth like a "sardine" to the transatlantic Middle Passage?), a razor that he will later use on his face to the scornful amusement of another man using a "real" razor in the Union Station restroom. Castration is associated, in this restroom scene, with a loss of white privilege. In his influential reading of "socialized" (and not natural, normative or universal) Oedipal desire, Raymond Bellour proposes that Oedipal narratives must resolve such castration. If this is the case then the film's resolution must also bear this additional burden (94, 31). Lastly, the porter is, like the policemen who earlier invaded the cabin, unaware of Grant's criminal presence. The porter epitomizes the docile service person — ingratiating, smiling, polite and clueless to

the illegalities and illicit activities carried out by those he serves. Yet the traditional anxiety about letting servants overhear what they ought not to hear is also referenced, as if to insist that his racial presence remain ambivalent, unreliable and unreadable.

The porter's appearance of docility conceals a sinister underside, for he also unknowingly conveys Grant's death sentence (the third attempt on his life) to foreign enemy agents when he carries a note from Eve to Vandamm. The other is once again coded as duplicitous. His servility can be pressed into the service of un-American activities as well as functioning as a disguise for indeterminate and even hostile intentions on the model of the ubiquitous Gray Suit. This association of African-American transport personnel with trains and death is prepared by Hitchcock's black-and-white film, *Shadow of a Doubt*. In this wartime film, the invasion of a homegrown criminal, Uncle Charlie (Joseph Cotten)—a "New York man [...] from the [North-]East"— into idyllic (read: white) Santa Rosa is prefigured by the black cloud of pestilent smoke his train emits as it pulls into the station.

Hitchcock here alludes to the train as the figural harbinger of a dangerous modernity in American Westerns, Ozu's films or Josef von Sternberg's *The Devil is a Woman* (USA, 1935). This "means of locomotion" is a threat, as is seen earlier in the film when the ominous motion of the train carrying Cotten out West is superimposed on the ingénue face of Uncle Charles's double, his niece Charlie. Uncle Charles arrives on this train to threaten the domestic war effort. War bonds are, for instance, prominent in the bank where Charlie's father works and whose aura of high-minded nationalism Charles scorns. So too, Charlie's beau and sister both stress that an America at war "needs watching" by a "government" that one is "not to talk against." Uncle Charles is posing as a dying man hidden behind dark curtains on the train to evade capture by the law and is quietly served by an African-American attendant who, like his double in *North by Northwest*, appears as an avatar of death. Uncle Charlie will conclude the

film by throwing himself off (or being pushed off) a moving train into the path of another. In other words, blackness threatens whiteness with the death that haunts it as a contingently "socialized" privilege (see Dyer 207-23). This imminent yet eternally deferred death sentence is confirmed by the last shot of Roscoe Lee Browne in *Topaz*. The actor is seen preparing a cross-shaped funeral wreath that seems to be mourning the passing of a white modernity.

To return to *North by Northwest*, Saint and Grant arrive in Chicago after a night of sexual abandon that will be legitimized by marriage in the film's final image. Grant then bribes a Red Cap for his uniform to pass a gauntlet of policemen. The authorities soon find the half-naked man and every Red Cap in sight suddenly becomes a suspect. A chase ensues in which Red Caps are uncovered as if they were suspected communists, homosexuals or other enemy combatants. The police state reigns supreme. Union Station is, however, curiously free of African-Americans, as several close-ups of accosted Red Caps reveal, although a middle-class African-American man is witnessed in the crowd leisurely talking to his white double. Class rather than race is targeted by the state, with the Red in Red Cap alluding to a fear of communist crowds, resistant masses and worker uprisings. The underclasses emerge as a fifth column within a state where the middle classes are being besieged from below and above. This assault from above is reiterated by James Mason's stellar performance as the latest in a series of upper-class Hitchcockian enemies within (i.e. *39 Steps*, 1935; and *Saboteur*, 1942). Anglophiles are apparently un-American.

Chapter 4

Racing Results

The word "uprisings," which recurs in *The Birds* in the singular, is legible in a newspaper in the Washington offices of *North by Northwest*'s United States Intelligence Agency. A glance at the other headlines in this paper will draw attention to the geo-political and socio-economic pressures at work in Hitchcock's film before I move on to the locus that focalizes them—the Chicago Stockyards. The headlines read: "Nation Fears Tieup / TWA Eastern Idle"; "Nixon Promises West Will Remain in Berlin / Tells British Appeasement Will Fail in Germany and Formosa Strait"; "2 Uprisings Reported"; "4 Flee Blaze in Northwest"; "Public Housing Gets Its First..."; and "Racing Results." The "Tieup" in the air travel industry registers potential labor trouble at home (TWA suffered a debilitating strike in the forties) as well as a threat to the mobility of capitalism stretching from coach to first class, from local to international networks. Anxiety is increased by Cold War tension vis-à-vis the USSR (Berlin) and Communist China (Formosa Strait). Yet the global lack of speci-ficity attributed to the "2 Uprisings" stresses that threats to the home front can originate from both within and without: say, from disgruntled underclasses massed in Corbusier style "Public Housing" or in the Pruitt-Igoe Housing complex (unveiled with much fanfare in 1955 in Saint Louis, Missouri, and demolished in 1972 as a testament to the failure of Modernism for the masses).

The next headline attempts to confine the internal and external violence that ripped Cary Grant out of the insular security of New York City, the capital of "North"-east, to a "Northwest" threatened by a disaster. This instability in the North- or Mid-west is nevertheless reconnected to racial and ethnic others in the NYC crowd by means of another "racing

result"—that is to say, a concern with providing "Public Housing" for these masses in the alienating modernist structures critiqued at the beginning of the film. The result of reading the newspaper is an insight into what must be aestheticized—race, geo-politics, crowds, uprisings, high-rises and the no longer beatific isles of a decolonizing world (Taiwan, the former *Ilha Formosa*, or "beautiful island")—as if forecasting the aestheti-cization that Hitchcock fails to impose on the Cuban Missile Crisis in *Topaz*. This crisis is headlined in a newspaper at the end of *Topaz* only to be thrown away, as if to suggest that the Cold War cannot be successfully transformed into an aesthetic monument. *Topaz* was doomed from the start, since the crisis was already over when the movie was released, depriving the MacGuffin of even a modicum of audience interest. The infinitely more successful *North by Northwest* integrates the news as a MacGuffin (the Cold-Warrior Mason), yet in a way that continues to trouble the closure that Hitchcock desires. The Northeast retreat Cary and Saint return to at the film's end is preformatted, instead, as an imaginary zone that will continue to be besieged from within and without.

The lack of any retreat from capitalist, industrial and bio-political processing is consolidated by the allusive presence of the Chicago Stockyards. Cary Grant's pre- and post-diegetic life will place him above the "Blaze" of the murderous Midwestern cornfield where he was deposited to be slaughtered in the middle of *North by Northwest*: a killing field where his immaculate Beverly Hills ("Quintano of Wilshire Boulevard," according to Cohan; 52) or Savile Row suit is so crumpled that Saint compares him to a worker in the Chicago Stockyards. Charles Patterson points out how the organization of transport to the Stockyards and the assembly line division of labor that efficiently processed meat for the market both served as a pattern for the anti-Semites Henry Ford and Adolf Hitler (72-3). This connection is explicitly rendered in the film when the "Blaze" caused by the crop-duster

plane "Crash[ing] and Burn[ing]" into an "Oil Tanker" after failing to kill Grant is described by a newspaper that Eve is reading as a "Holocaust."

The inhuman processing of "a steady stream of carcasses" by the highly rationalized stockyards desensitized laborers to their bloody work, as Upton Sinclair dramatized in his 1905 polemical tract-novel, *The Jungle* (39). Workers, in being dehumanized by animal suffering, imperil their own humanity by becoming nescient cogs in a capitalist machine, according to Sinclair's text, reissued in 1946 as a "cry for social justice" to be "heard around the world" (x-xi). This processing of cars, humans and animals by the industrial, bio-political and capitalist rationalization of labor produces an acute desensitization of humanity confirmed on an everyday level by the nonplussed ingestion of meat.

Hitchcock was an avid carnivore, a pre-requisite for the Western lover of superrich wines and gourmet food that he fancied himself to be. This obsession with aestheticizing slaughter on a daily basis became, however, grotesquely self-evident on his move to America. The USA is, after all, the home of the Chicago Stockyards and Fords, a territorial desert of rampant industrialization, consumer culture and enforced obsolescence that *Psycho* (1960) maps via a used car lot. The question that arises, then, is how to continue to aestheticize what Hegel called the "slaughterhouse of history," whose future was, as the philosopher prognosticated, to be found in America, once Hitchcock set up shop in Hollywood (69). A reading of his final British film, *Jamaica Inn* (1939), as a farewell to "Europe" will foreground how Hitchcock staged this adieu in relation to the conflict between Old-World aestheticization and America's post-war emergence as an impediment to sublimation. America emerges as a wholly disenchanted military, capitalist, industrial and post-industrial superpower typified by the post-industrialism of Madison Avenue and Hollywood—both of which are connoted by Cary Grant in *North by Northwest*.

Jamaica Inn is not as bad as its reputation. On the contrary, Charles Laughton's performance as an absolutely decadent country gentleman who takes to murder and robbery to sustain his Byron-inflected lifestyle is a joy to witness. And decadence is what this film—set in 1819, the year radicals almost rose up against a triumphal post-Napoleonic British order—is all about (see Chandler). Laughton's squire outdoes Mason by being genuinely concerned for his poor tenants, unlike the gentry in Hitchcock's *The Skin Game* (1931), yet he also has the egalitarian revolutionary run out of town. The squire refuses to recognize the anachronism of aristocratic excess. On the contrary, he masterminds the murder of British Navy sailors by a gang of thieves in order to continue funding his chivalric lifestyle. He longs for nothing but a fine table, sheer conviviality and "beauty" in both horses and women. He even crosses the racial line by citing Shakespeare's description of Othello's adventures as a self-description: "Of moving accidents by flood and field, / Of hair-breadth scapes i' th' imminent deadly breach" (*Othello* 1.3.36-7). Laughton pictures himself as a Romantic hero in the Byronic mold—"The wandering outlaw of his own dark mind" (*Childe Harold's Pilgrimage* 3.20)—or as a Western fantasy of blackness as anarchic life (*Othello*) to which I will return. Yet his plan to kidnap beauty, to bind the heroine of this film and take her to France as his love-slave, fails. "Be beautiful," he bellows at her, "hard if you must be, but beautiful." Laughton is hunted down by the Navy and prevented from escaping England. He ends up throwing himself from the ship's mast, where the Navy has cornered him, with a final defiant exclamation: "What are you all waiting for? A spectacle? You shall have it and tell your children how the great age ended."

Laughton "mak[es] Death a Victory" on the model of Byron's "Prometheus" (line 59). His adieu echoes his earlier exhortation to his unwilling mistress, "Well, you have to be hard now. The age of chivalry is gone," a citation of arch-conservative Edmund

Burke's famous phrase, "The age of chivalry is gone... and the glory of Europe is extinguished forever" (*Reflections on the Revolution in France* 66).[10] Burke published his elegy for chivalric ideology in 1790 at a time when the French Revolution was threatening to remove the trappings of raw power ("chivalry," royalty, the state church, etc.) This reduction of neo-feudal trappings to mere performatives would be consolidated by Napoleon's self-glorification as Emperor of the French. In *Jamaica Inn*, we find ourselves in a post-Napoleonic England that is not yet fully under the rationalizing control of the state. Rogue gangs prey on shipping, as the film's introductory title tells us, because the Coast Guard is not yet in effect. Yet 1819 is disenchanted enough by Napoleon's specter that "chivalry" and all the aesthetic traps associated with it are rendered obsolete. Laughton reacts to this enforced obsolescence or cynicism vis-à-vis chivalry by aestheticizing murder as a fine art. He echoes conservative Romantic Thomas De Quincey's ironic attempt to re-aestheticize existence through violence in *On Murder Considered as One of the Fine Arts* (published in 1827 in *Blackwood's Magazine*). De Quincey resurfaces, of course, in *Rope* when the aesthete murderer Rupert states that "Murder is—or should be—a fine art." Laughton's lucid, lurid and murderous aestheticism is, however, less private and inwardly turned than that of *Rope*. It must be neutralized and contained as "mad" rather than being allowed to emerge as a prescient criticism of the Romantic-era passing of pomp into cynical performatives.

Jamaica Inn can plausibly be read as Hitchcock's farewell to England and Europe—that is, to a post-World War II situation where real power has moved to America, leaving only the shells of decayed rituals behind, such as the bombed-out London courthouse in *The Paradine Case* (1947). America becomes the space where Hitchcock will re-ritualize existence through an aestheticization of violence, rape and murder. For Hitchcock, to aestheticize is to admit and deny, as Richard Allen has recently

argued in *Hitchcock's Romantic Irony*, topics that trouble his films. These topics include, for Allen, sexuality, as will soon be explored, along with race, ethnicity and crowds, according to my argument so far. What must be admitted and denied are the connotations accruing to the carcasses that litter the Chicago Stockyards. Laughton loves to live large and when his valet hounds him with overdue bills from the baker, the butcher and other merchants, his outburst expresses how "carcass" serves as a code word for what must be aestheticized—the violence of money, power and enforced labor: "A remarkably unattractive occupation Chadwick, drearily dismembering carcass after carcass." "I suppose they must live," his servant Chadwick replies. "Must they?" drawls this self-described "Man of Sensibility," eighteenth-century avatar of the nineteenth-century aesthete. Laughton in *Jamaica Inn* epitomizes, in sum, an equivalency between the expendability of animals and humans that will be focalized by the Chicago Stockyards in *North by Northwest*.[11]

Laughton is unperturbed by this equation. He is willing to kill anything, including naval and civilian sailors as well as the beautiful fetish-object he has abducted. He would, as he informs her, "rather see you dead," than mother to a "dozen sniveling dirty-nosed brats." He wants to persevere in his anachronistic aesthetic state of fantasy to the point of perversity, sadomasochism, fetishism, murder and death. Life, for Laughton, as for Joseph Cotten (Uncle Charlie) in *Shadow of a Doubt* and Anthony Perkins (Norman Bates) in *Psycho*, is socially reproduced death. It must be aestheticized at any cost, as Cotten explains when he justifies his slaughter of rich widows. "But they're alive," niece Charlie interjects, "they're human beings." "Are they? Are they, Charlie? Are they human, or are they fat, wheezing animals? And what happens to animals when they get too fat and too old?" Laughton continues to unpack the bio-political baggage of Hitchcockian aestheticism when he recycles the word "carcass" to refer to the elimination of the expendable

rogues that his Romantic plans require: "In this little organization you and your fellows are only the carcass. We are the brains right here." They "must," in other words, die rather than live, a textbook definition of bio-politics.

The year of *Jamaica Inn*'s release was 1939, causing "carcass" to resonate with a word "in Germany" and other "Strait[s]" of war (to re-cite the newspaper in *North by Northwest*). "Carcass" alludes both to the subhuman bodies of the enemy (Russian, Jewish, Slav, and other so-called *"Untermenschen"*) and to the expendable bodies of German soldiers.[12] It was the mass conscription jumpstarted by the French Revolution that allowed generals to regard men as fully expendable in this way. If Napoleon's signature attack—targeting the enemy's center *en masse* once the flanks had been weakened—indicates the gross human cost of this Revolution in Military Affairs, it was a geopolitical sacrifice that Hitler was more than willing to pay. The instrumentalized expendability of life haunts both the aesthetic drive and the rationalized state, as applied in Jamaica and other territories by a British empire whose racist structure Hitler was reluctant to dislodge (Rich 157, 226). In having his Holocaust-damaged suit *re-pressed* (in a Freudian sense) by "invisible" workers, Grant re-effaces this genealogy of American bio-politics. He admits it only to bury the unpayable price for his star status, his classless class. Who, if anyone, occupies this impossible high-angle or god's eye view: the director, the star, the viewer? What is the complexion of this place and who is large enough to occupy it?

The all-too-large Laughton occupies this place above it all only to cast himself into the abyss that Grant rescues Saint from at the end of *North by Northwest*. Laughton is unable to set sail as an exile in imitation of Hitchcock's ability to transpose himself and his refined aesthetic tastes to America. He despises marriage and the bio-social reproduction that it empowers, yet marriage is the only institution that can offer closure in *North by Northwest*.

Hitchcock wants to legitimate both marriage and anarchic sexuality, yet the uprisings, blazes and racing results that the newspaper in *North by Northwest* attempts to segregate in a "Northwest" populated by internal and external others cannot be contained. These unpredictable events continue to disturb the Hitchcockian will to aestheticize sex, the state and the bio-political order of High Capitalism. What is truly disturbing is that this order of things is, as *Psycho* emphasizes, identical with everyday life itself in an America where a nice old lady is concerned that the pesticide she is about to buy is "guaranteed to exterminate every insect in the world" in a "painless" manner. In this scene, pesticide is a stand-in for the American state's power to impose capital punishment under the sign of a *faux* humaneness. It is this contradiction in terms—a humane bio-politics—that it then wishes to extend to "every" human and animal creature in America and beyond: "And, I say, insect or man, death should always be painless."[13]

Chapter 5

"I've got you, Mrs. Thornhill"

North by Northwest ends with a remarriage—Thornhill's third—that seems to effectuate what Cavell demands of a genre he invented, the comedy of remarriage: a scenario where "the sexual and the social are to legitimize one another" (*Pursuits* 31). Cavell's reduction of *North by Northwest* to "the legitimizing of marriage" in an eponymous 1981 essay is based on the Oedipus complex ("*North*" 763). This dependence on "a psychoanalytic characterization of human motivation" or a "debt to Freud" is, however, as Richard Allen notes, "never systematically outline[d]" in Cavell's work on Hitchcock ("Hitchcock and Cavell" 46). Instead, Cavell interprets Roger O. Thornhill's "trademark" initials—ROT—as an allusion to "Hamlet's sense of something rotten," which leads, via a citation of Ernest Jones's *Hamlet and Oedipus* (1949), to an admission of the "blatant presence of Freudian preoccupation and analysis in Hitchcock's work" (766-7). Cavell's collegial, conversational and anti-systematic style shies away, however, from the Freudian preoccupations that he is pursuing as too "obvious" (767). Namely, Thornhill moves from immature dependence on his mother, and the adolescent "acting out" this implies (i.e. the regressive drinking of "liquor" that Cavell regards as a "grown-up" pleasure), to a substitute mother or wife (765). This shyness is, however, revealed by the symptomatic way in which he approaches the "question" of whether Oedipal hermeneutics are or are not being imposed on Hitchcock (767). The question is all-too-obviously relegated to a footnoted bracket:

> Hitchcock would not be the first artist of this century to feel that he has to pit his knowledge of human nature against the thought of the man who is said to have invented its science[3]...

3. Even Raymond Bellour's useful and sophisticated study of *North by Northwest* ("Le Blocage Symbolique," *Communications* 23 (1975): 235-350), judging from one hurried reading, has not, it seems to me cleared itself on this question. My remark is directed only to the first half of this monograph-length paper. The second half, devoted to the geometry of the crop-dusting sequence, I have not looked at sufficiently to have a judgment of. (767)

By calling psychoanalysis a "science" and caricaturizing Bellour's study as "geomet[ric]" — and thus, apparently, not worth reading with care — Cavell positions himself as a plain-speaking antidote to French systemizing. If this misrepresentation of psycho-analysis as a "science" has been contested by many, including both Lacan and Derrida,[14] Cavell's covert dismissal of Bellour's study as "geomet[ric]" — a codeword for "Cartesian" or "French" — reinforces an Anglophilic pose that is consolidated by his 1984/88 reprinting of this footnote verbatim as if there had not been enough time to do a close-reading of this influential analysis in the meantime (see *Themes* 152-72). Cavell's reading remains, of course, Freudian. It is as Oedipal as can be in that he traces a movement from Hamlet-like indecision and confusion vis-à-vis the mother — Thornhill's "running [...] away from his mother," his "unresolved anxiety about getting a message to his mother," or "certain guilts acquired," such as "efforts to keep the smell of liquor on his breath (that is, evidence of his grown-up pleasures) from the watchful nose of his mother" — to action, adulthood and marriage (763). According to this American state of fantasy,[15] through service to "America" Thornhill becomes a man by becoming a husband, or by "finally get[ting] a message through to a woman, the difficulty of doing which began this plot" (775). What bears emphasis is that Cavell's movement from mother to substitute mother is also based on a "running away" from "unresolved" anxieties; in his case, on the legs of a "hurried

reading" of Bellour's text and a concomitant refusal to return to a text that Cavell is unable to form a "judgment of." And so I turn to Bellour's "Symbolic Blockage" in order to see what Cavell is fleeing from, which will turn out to be a systematic version of his own symptomatically Oedipal argument.

What seems to block Cavell's desire to treat Bellour "fair and square" (a citation of the plain-speaking car dealer in *Psycho*) is that the French critic traces the Oedipal trajectory very carefully while also admitting it to be a contingent social formation, or an internalized instance of ideology-in-action:

> it is by signifying the relationship that links him to his mother that the hero finds himself logically carried toward the possession of a wife: Eve, the woman. This substitution, at the end of an ordeal in which the hero completes his itinerary (which may be justifiably called "Oedipal") opens the way to the *jouissance* symbolized by the last shot. (Bellour 81)

The final money-shot does this ideological work by conflating the social legitimation provided by the patriarchal institution of marriage with insensate intercourse, or with the *jouissance* telegraphed by a train roaring into a tunnel. "C'mon. I've got you. Up. Yes, you can, c'mon. Come along Mrs. Thornhill." These words make, according to Bellour, this repetition of a deception-riddled one night stand (*jouissance* or coming) on a train into a "licit" thing by renaming Eve as an *ersatz* mother:

> "Come on, Mrs. Thornhill". They show that the transgression of the adventure closes with the sanction of bourgeois marriage, but they also indicate that the limit where desire is fixed can only find recognition in this transgression as trial and site of truth: the loss of identity and the guilt that from the inaugural mistake defines the adventure as the traversal of an enigma thus lead the hero from an ignorance to a

knowledge, from a lack to a possession, from the misrecog-
nition to the recognition of (socialized) desire. (81)

The "transgression" Bellour has in mind is the murder of the
father, or the killing of the real Townsend, which Cary Grant is
falsely accused of after being mistaken for Kaplan. Since the fake
Townsend (James Mason) possesses the mother-substitute, Eve,
as his mistress, Bellour's logic is inescapable. It is only through
the combination of this false murder of the father withholding
Eve and his own staged death at the hands of Eve that Cary Grant
can become a man by possessing Eva. He must, according to this
bio-political imperative, accept symbolic castration: death, lack
and primordial loss. Yet for Bellour this acceptance and the
implied commodification of Eve as Eva or a Hollywood star is
merely one more "recognition of (socialized) desire." It is yet
another misrecognition insofar as Oedipal desire is a Western
social formation tailor-made for making men believe that they
have legitimated their rampant sexual anarchy. This "legiti-
mation" of an illicit encounter on a train is confirmed by the
mirroring of this socialized desire for "erotic" adventure in the
last shot. The film's conclusion permits us to witness, according
to Cavell, a fantasy uniting sexual transgression and the
socialized "fight for recognition (as Hegel put it) or demand for
acknowledgement" (Cavell, *Pursuits* 17).

For Cavell, Grant accedes to this symbolic mandate by serving
"his country" even though his nation-state is content to let him
and Saint become carcasses in the interest of national security. It
is this symbolic accreditation that hyperlinks the institution of
marriage to a bio-political humanism in which Cary Grant must
both "save himself and save his country's secrets from leaving it
and thus win himself a suitable mate" (*"North"* 768). The name of
this murderous bio-political state, where the comedy of remar-
riage concludes on the high note of bio-social reproduction, is
"America": "their goal is the thing I call the legitimizing of

marriage, the declaration that happiness is still to be won there, there or nowhere, and that America is a place, fictional no doubt, in which that happiness can be found" (774). Yet is happiness the same as *jouissance*, or has the sexual been left behind, denied or repressed by an argument that resolves "unresolved," unadmitted and disavowed Oedipal "anxiety" only to place this resolution in scare quotes? If these bracket marks demarcate the inexhaustible reflexivity of a fictive or self-conscious Modernist artwork, where, then, can sex be found in Cavell's reading except as a resolutive fiction? In order to approach this question we must turn to Christopher D. Morris's "The Direction of *North by Northwest*," a deconstruction of the destination ordained by the Hamletian-Oedipal "itinerary" of Hitchcock's film.

For Morris, the "allusion" to a line of *Hamlet*—"I am but mad north-north west" (2.2.379)—is undermined by the "groundless" lack of direction excavated by the film. This contingency of directionality is supported by the fact that the title *North by Northwest* was suggested to the director by a publicity man at MGM as a replacement for Lehman's awkwardly ambiguous *In a Northerly Direction*. Morris's argument calls on Derrida's *La Carte Postale* (*The Post Card*), where Derrida argues, contra Lacanian psychoanalysis, that any letter (signifier) might not, after all, reach its destination. Morris's stress on an ultimate lack of direction is confirmed by the "unreadable face" of either Grant or Saint, as well as by the other deconstructive instances of the interruption of interpretation, meaning and language that he notes in the film (50). The "message" Thornhill supposedly gets "through to a woman," reads, according to both Cavell ("*North*" 775) and Bellour, "Be my substitute mother." This message marks, in turn, an effort to unite sexual ecstasy and "socialized" recognition, yet Morris's analysis of the "postal" places the successful arrival of this message at its destination in doubt. Sex does not come and is displaced, instead, by the last shot. If Hitchcock's comment that the last shot is a "phallic symbol" is

ritually cited by both Cavell and Bellour, this comment has, as Morris writes,

> the effect of equating the act of intercourse with a blank or absent referent which must be—like everything else?—"filled in" with interpretation. And the interpretation in this case renders the ending even more ambiguous, since "intercourse" is the ultimate signified of the Hollywood happy ending, the extracinematic part of the film that lies beyond the closing embrace. Converting such a "transcendental signified" into a visual trope ensures that it can be understood only as part of the contingent, always interrupted postal: as the screen fades out we have indeed, coitus—like interpretation—interruptus. (51)

If *jouissance* embodies a Real "which resists symbolization absolutely" (Lacan 66) and escapes language—cinematic language included—it also underpins socio-symbolic meaning and ideological capture by fictions or state fantasies. A perfect example of this nation-statist fantasy dedicated to covering over an absolute lack is the classless "*idea* of America" or "its promise of liberty and equality" that Graham McCann constructs in his highly ideological biography of Grant (57). The in-your-face presence of the "visual trope" or "phallic symbol" supplements this "blank" or resistant absence by invariably producing jubilation in the audience. Yet this delight is usually accompanied by titters of laughter in response to the sheer audacity of Hitchcock's envoi. This is the "extracinematic part of the film" that ought, according to ideology, to finds itself reduced to the debased yet no less symbolically efficacious form of a joke. This reduction is perhaps inevitable since the *jouissance* of "intercourse" will always be too traumatic for cinematic language, as is marked by the frenzy of the visible interminably ejaculated by literal money-shots in pornography (see Williams).

Richard Allen has recently shown how important visual playfulness is to Hitchcock as a way of maintaining lucidity, destination and direction vis-à-vis the traumatic, or the traumatism communicated, in Allen's case, by sex itself. Visual tropes or jokes function, as we will see, as Allen's covert way of managing the supplementation of both sexuality and sexual trauma by racial and ethnic traumatism. According to *Hitchcock's Romantic Irony*, the director depicts romance as "triumphant" in an ironic manner so that "at the same time, the impossibility or vacuity of romance is revealed" (101). Irony has its cake while eating it too by displacing sexuality into style. In Hitchcock, the "ideal" of "heterosexual romance" is "entwined with its opposite—human perversity," as Laughton, Cotton and Perkins demonstrate. Yet the "profound anxiety" produced by the perverse sexuality inhabiting romantic love is kept at bay, for Allen, by irony: "human sexuality, deemed by definition perverse, is self-consciously displaced into style in the manner of the Freudian joke that at once disguises and reveals its sexual content" (11, xv). In *To Catch a Thief* and *North by Northwest*, Hitchcock uses, according to Allen, a second way of managing the perversions begotten by sexualization. The "anarchic force of human sexuality" is used to "fuel rather than undermine romantic renewal," as opposed to the ironic ambivalence vis-à-vis *jouissance* that avoids undermining it in a "majority of works," including *Strangers on a Train* (1951), *Rear Window*, *Murder!* and *The Lodger* (13). There is also a third way in which romance is "infected or undermined by the forces of human perversity," only to generically contain these forces by means of the "tragic" in *Vertigo*, or the "darkly comic" in *Psycho* (13). As far as Allen is concerned this watering down of sexual perversity by the "romantic-ironist or aesthete" is a good thing. It appears that our only other option is to be awash in unsublimatable seas of sexuality (xiii), yet there is a racial dimension to the problem that he seems to have temporarily sidelined.

In an earlier article on *Murder!*, Allen marginalizes the question of race by reading race as a coded reference to homosexuality. He concludes that *Murder!* fails to deal with "racial discourse" except in an "imperial" or "unresolved" mode ("Sir John" 121). The narrative fact that the "half-caste" Fane dares to desire that a white woman play a starring role in a Hollywood happy-ending uniting sex and marriage is the "unresolved anxiety" (Cavell's phrase) engaged by Allen's text. Another name for this "anxiety" is intercourse exacerbated by the traumatic possibility of interracial commingling.[16] The "racial category of half-casteness" is, Allen argues, "only a pretext to dramatize an aspect of identity—human sexuality—that Hitchcock is more interested in, indeed, obsessively interested in" (*Hitchcock's Romantic Irony* 122-3). Yet "human sexuality" includes the trauma of interracial marriage (for example, and this is not merely an example, *Othello*) that continues to obsess the Western racist imaginary.

The threat of interracial sex is mastered in *Murder!* by Fane's "staging his own suicide" (Allen, "Sir John" 107). Like Laughton, Cotton and Perkins, the threat that his perversity poses to the normative reproduction of the bio-political state is fantasized away by Fane being forced to internalize a recognition that he must be put to death. This self-cancellation identifies Fane with the suicide of Laughton and the semi-suicide of Cotton. Another option for threats to national security is medical or penal incarceration, as in the case of the normal man Norman Bates played by Perkins. Fane's suicide scene is, Allen argues, ironized by a "self-conscious artifice," or "a playfully ludic style that alludes to human perversity indirectly in the manner of a Freudian joke that at once refers to and disguises sexual content through word-play" (110, 107). The joke may be on Allen, however, in that the word-play between "inter-racial" and "inter-course" points to a trauma that cannot be so readily aestheticized. The trauma of interracial intercourse throws a wrench into an American reliance

on marriage as a way of resolving the "problem" of racially and ethnically diverse crowds. This problem is rendered even more unmanageable, as we will now see, by the interracial alliance between a blackfaced Grant and a superwhite blonde named Grace Kelly in *To Catch a Thief*.

Guess Who's Coming?

What will happen to Grant and Saint's characters once they return to New York City to live as a married couple in the shadow of divorce, the condition, after all, for the virtually endless possibilities of remarriage that Cavell gleefully envisions? They will share a whitewashed consumerist world where ethnic and racial others are admitted only as invisible or unrecognized service persons. The itinerary of *North by Northwest* processes both this anxiety of being encircled by "unreadable" others and the trauma of the other coming (racialized and interracial *jouissance*), so as to live happily ever after in an insular world haunted by racist fantasies of home invasion, bodily violation, rape and race war (Tippi Hendren is conveniently a figural victim of all four in *The Birds*).

This prototypical Hollywood narrative trajectory recurs in the late nineties. In *Sleepy Hollow* (dir. Tim Burton, USA, 1999), Johnny Depp's character confronts a menstrual, maternal womb-tree and an obscene father of perverse enjoyment terrifyingly embodied by Hollywood's resident psychopath, Christopher Walken. In the last shot, Depp triumphantly returns to a nineteenth-century New York City in which he will educate Christina Ricci in the pre-Civil War social geography of the city they are to occupy. They are to live and love happily in an eternal deferral of post-Civil War racial strife, the Civil Rights movement and race competition for social capital, such as the prized Manhattan apartment that Depp assures Ricci they inalienably possess. *Sleepy Hollow* is therefore also an allegory of the endless psychomachia required to access a decent apartment in New York in the nineties.

Fifties-era Manhattan is, in contrast, full of mixed crowds

threatening the segregationist institution of marriage with inter-racialization. "There are," as Elias Canetti writes in *Crowds and Power*, "no institutions which can be relied on to prevent the growth of the crowd once and for all" (32). This "massing" threatens a "massed attack" (to cite cognates used in *The Birds*)[17] on "the future of the race" (Allen, *Hitchcock's Romantic Irony* 77). Leslie Brill's combination of Canetti and Hitchcock also detects a threat to the "procreative connection between the heterosexual couple and the potential growth" of an implicitly white crowd that he locates in the "final setting" or "conclusion" to *North by Northwest* (141-2, 128). The crowds of New York remain, in Brill's words, "menacing" to the fantasy space of the white, hetero-sexual "individuals who make up the couple" that will fail to conclude, resolve or finalize *North by Northwest* (142).

This menace is also legible in Cavell's position. According to Allen, Cavell is skeptical whether we can know with certainty "our relationship to other people and the world." He therefore proposes "recognition," "response" or "acknowledgement" as "a form of attunement with others" that "characterizes the way we exist with others in the world in a manner that is not based on knowing" (Allen, "Hitchcock and Cavell" 43). The only way to find "recognition," a word Bellour also uses, or to overcome the "failure of acknowledgement" and "isolation," is through "a relationship between equals, as in the cinematic genre Cavell identifies as Comedies of Remarriage" (45). Cavell converts skeptical isolation into an *isle à deux* that remains unequal, since Thornhill will, like a good paternalist, "educate and hence rescue the woman" in order to "achieve happiness for them both" (Cavell, "*North*" 775).

An article by George M. Wilson that Cavell refers to in his *North by Northwest* essay complicates things further by stressing those who cannot be recognized or acknowledged: "herds of city dwellers" or "similar crowds and *clumps* of people," "especially in the train station and at Mt. Rushmore," masses who in "their

very anonymity" are "both ambiguous and threatening" (1164; emphasis added). "It is almost," Wilson writes, "as if people were interchangeable as long as they fit into a system of expectations and appearances in the right way"; "governments, advertising, and the media" are, he elaborates, "faceless, anonymous and covert. Only their handiwork is invisibly visible no matter where one looks" (1166). Cavell's couple will be surrounded by a capitalist, post-industrial and bio-political "system" where invisible others will serve their consumerist and security needs or pass as white. Yet the couple's *carte blanche* provides no guarantee that they will not be victimized by this system if and when it decides that they are either a threat, as gays and communists were considered in the fifties, or expendable, as Grant and Saint's characters are in the cold eyes of the United States Intelligence Agency.[18]

The film's cooptation of sexual anarchy tries to defend itself against any awareness of this menace to white privilege in the fifties, a menace that will bloom into full-blown White Panic in Tarantino's cultural work. The return of Grant and Saint to New York City as a radiant center of capitalism and consumerism is threatened by the ambiguous directionality of the final shot: two arrows point out in different directions from the letters of the film's superimposed title, diverging from the Northeast direction in which the train is ostensibly heading. America as a territory, fictional or not, is derailed. Conjugal closure is exposed as a shared isolationism existing nowhere in particular "as if marriage were a presence of mind" (Cavell, "*North*" 775). In order to open this groundless fiction to the sexual, racial and ethnic traumas that it is disavowing, I turn to how fictions of ethnicity effect this disavowal. Cavell's anti-French and Anglophilic pose will, for example, be seen to insist that there is a place, a high angle or *Anglo*, if you will, far from madding crowds, massing masses and uprisings of all kinds.

How are we to explain the tenaciously held *doxa* that

Hitchcock and Grant are really and truly English in spite of either their citizenship (half-British in Hitchcock's case, American in Grant's), or the obvious relish they expressed in living, working and playing in an America free from the British half-caste system in which they occupied a lower berth? This *doxa* exemplifies a disavowal, as does a comment Cavell makes when extolling America as a conjugal fiction that will enlighten the weighty philosophical problems of skepticism and solipsistic isolation, acknowledgment and recognition. "*This* Englishman," as he writes in a bracket in reference to James Mason's character, Vandamm, "does not belong to this place but owns a structure mythically close to it, pitched out from the land." It is, as Cavell continues, "less a dwelling than a space station" hygienically isolated from the debased tourist trap surrounding the "monument to America" also known as "Mount Rushmore" ("*North*" 773). If the aura Mason projects in *North by Northwest* connotes Englishness—for example, the nostalgic feudal manor and rigid class hierarchy he seems to benevolently preside over in the manner of Charles Laughton in *Jamaica Inn*—Vandamm has a very foreign name and is never associated with Britain, let alone England. In fact, his name recalls Vandamme, a ruthless Napoleonic general and therefore a threat to Britain in a previous era of invasion panic. He is no more English than the Cambridge-trained, upper-class-accented Russian-American Vladimir Nabokov.

Nabakov, trilingual from an early age, comes to mind since Mason would soon accept a role that Grant declined as "degenerate" (qtd. in Eliot 478): Humbert Humbert in *Lolita* (dir. Stanley Kubrick; based on a Nabakov script, USA, 1962). Humbert, a Swiss-English academic raised in Paris, is a highlight in Mason's career that forever identifies him with a degenerate foreigner passing as an "English" pervert in America. Mason, who preferred, like Nabokov, to live in Switzerland rather than Hollywood (1963-84 and 1961-77, respectively), appears, of

course, far more English, or at least cosmopolitan-European, than either Grant or Hitchcock in the narrative. Both the star and the director fall away, as we have seen, from whiteness into the racial abjection and contestation vehiculated by public bussing. Yet the need to redeem their contested identity-fictions does not justify Cavell's italicization of Mason's Vandamm as an "Englishman." Moreover, his "dwelling" is hardly a "space station," although the term does transmit the desire to ascend high above the abjected American territory conveyed by his High Modernist, Frank Lloyd Wright-style edifice. *North by Northwest* perpetuates, in sum, an abjection of Anglo-whiteness that Cavell refused to acknowledge by relocating it in "a structure mythically close to it, pitched out from the land." I will now trace the consequences of Cavell's disavowed acknowledgment by turning to the racial and ethnic disturbances visible in *To Catch a Thief*.

Chapter 7

Post-Racial Ornamentalism

In *To Catch a Thief* Grant plays John Robie, a reformed American jewel-thief living it up on the Riviera. Before he appears, we see his double, a black cat, prowling the rooftops and linking Grant with blackness as well as with the stereotype of the black man as thief. In *Lifeboat* (1944), for instance, the African-American actor Canada Lee is typecast as a pickpocket. When a cat burglar begins to *rob* rich white tourists, Robie must clear his name of its racial association with blackness. He is a typical Hitchcockian "Wrong Man" (see *The Wrong Man*, 1956), falsely accused of being a "Wrong One." The latter term is part of the policeman's profiling apparatus in *Psycho*, an apparatus which he unhesitatingly applies to a lily-white Janet Leigh. Grant seeks to exonerate himself from being profiled as a "Wrong One" by passing as Conrad Burns, an affluent American "lumberman" from the "Northwest," in an attempt to lure and catch the true thief. The name "Burns" puns on both an unnaturally tanned Grant and a burnt Hamlet who has been "too much in the sun"—that is, on a hybridized figure whose skin literalizes Hamlet's "suits of solemn black," "woe" and Oedipal anxiety as if he were Othello (1.1.78, 86). A burnt Grant quickly contrives to meet the impeccably unburnt Frances Stevens (Grace Kelly), whose mother's jewels he plans to use as a trap for the real thief.

Grant and Grace begin a romance instigated by her romantically racialized view of him as a cat burglar with, in her words, "your face blackened." Grant's ungrounded ethnic identity is stressed in a scene where they share cold chicken in her automobile, both of them estranged from their identities by their ironic reflections in the car's mirrors. "You're just not convincing John," she informs him, "You're like an American

character in an English movie. You don't talk the way an American tourist ought to talk. You're just not American enough to pull it off." Grant appears to be dangerously "un-American," a word he characteristically guffaws in *The Philadelphia Story* (dir. Georges Cukor, USA, 1940). He is, as a presumably English actor in an "English movie," not "convincing" enough to be either "American" or "English." He is what Roger O. Thornhill's middle name stands for in *North by Northwest*: nothing. Or, as Audrey Hepburn tells him in *Charade* (dir. Stanley Donen, USA, 1963): "You know what's wrong with you? Nothing." She means it positively, but "nothing" can also be read as a Shakespearean pun. This nothingness is what is wrong with Grant. He is all mask and no identity, sartorially destined to elegantly slip into racial abjection.

Grant, to return to the narrative of *To Catch a Thief*, then participates in a masked ball where there will be a surplus of rich, bejeweled women to bait the actual cat burglar. Spectacular women are introduced to a camera that desexualizes them by focusing on their jewels. Grace Kelly and her mother (Jessie Royce Landis, Grant's mother in *North by Northwest*) enter dressed as pre-1789 aristocrats accompanied by Grant, who is not, strictly speaking, "in blackface," but in a black mask, posing as their Moorish parasol-bearer (Cohen 2. 210). He is identified as a blackamoor or Othello figure, whose dirty job is to keep the sun off his mistresses, or to keep them unnaturally white. Tanning is only for Grant. Kelly is to remain burn-free. The überblonde appears as an epitome of whiteness, yet this impossible ideal is constituted by her formal difference from the blackamoor. This difference is formal, abstract or disembodied in that blackface residually references a privileged white person playing at being black while the mask blackens whiteness altogether by effacing the embodied tactility of the disguised face behind a formalized abstraction.

Eva Cherniavsky's analysis of how the whiteness of the female

Hollywood star is constructed in relation to blackness elaborates this formal difference in relation to the abstractions produced by High Capitalism. Cherniavsky notes the historical

> transmutation of white bodies into commodities—more particularly, into an anticipation of what Mitsuhiro Yoshimoto terms the "commodity-image," an ideal because absolutely ephemeral object. The movie star as mass-mediated icon, whose glamour and allure are crucially staked on the "dazzle" of whiteness (in Gilroy's phrase), thrives in the context of its own impossibility: the most lustrous white skin cannot properly signify whiteness—cannot signify the white subject's property in the self—which circulates as a detached and exchangeable image. (xxv)[19]

The jewels in this scene refer to female sexuality as a euphemism, visual trope or joke on the female genitals (*Schmuck* in Freud's German). The women wearing them are thereby disembodied and desexualized, as if the "dazzle" of an ideal white woman were as detachable and "exchangeable" as a dazzling accessory connoting superrich status. There is a bejeweled non-white woman visible in South Asian or Indian dress. It is not, however, her fictive Aryan racial ascription that integrates her in the procession, but the commodity-images connoting whiteness that she wears. Jewels are to women what the suit is to the man and, like the suit and Grant's unnatural tan, this commodified "property" can be expropriated by others on both a global and local level.

If everyday whiteness circulates in a disembodied way in *To Catch A Thief* (*TCAT* = t'cat = the black cat, or yet another pun blackening Cary Grant's image), the "star" is also "transformed from an object of visual consumption into a figure of consumer pleasures," threatening a "disintegration of white embodiment through an overproximity to commodity culture" (Cherniavsky

xxv, xxvii). The performance of white femininity is reduced to the same nothingness as Grant: a figure for the lonely consumer crowd. This reduction includes the star Kelly, the most graceful or Europeanized American star imaginable even though her character admits that she and her mother are "just common people with a bank account." Whiteness can be bought and sold for expensive yet not exclusive prices. It emerges as no more than "a figure" for this obscene freedom to purchase and consume nothingness.

The white star is also free to enter into interracial alliances, as Rita Hayworth did when she married the Prince Aly Khan in 1948 (the third of her five marriages), an interracial version of the sexual freedom to which Hollywood royalty were entitled that was reiterated in a finer tone when Kelly married the Prince of Monaco in 1956. Although this freedom was rigorously policed — Hayworth's successor at Columbia, Kim Novak, was, we recall, prevented from marrying Sammy Davis Jr — it also establishes the absolute distance between superrich celebrities and the American consumer of their auras and commodity-images insofar as such alliances remain taboo for the masses. They must consume the interracial sexual transgressions that they condemn and desire — to the point of white death — at the safely and impotently insulated distance imposed by theatrical seating.

Whiteness is further disintegrated when Grant's blackamoor disappears to fetch mother's pills and returns to dance the night away with Kelly. Their staying power exhausts every other dancer until even the band calls it quits. "No one can like the drummer man," as the minstrelized white band sings in *Young and Innocent*. Since dancing is often a Hollywood encryption for sex under the Production Code, we are obviously witnessing an interracial coupling. Yet no one prohibits the ur-trauma of "an old black ram" relentlessly "tupping your white ewe!" (*Othello*, 1.2.87-8), as if to re-insist on the phantasmic interracial license accorded to Hollywood stars. Grant has, of course, been doubled

in the meantime by an English insurance man from Lloyds so that he can lie in wait elsewhere for the thief. When *this* "Englishman" removes his mask traces of blackface remain on his skin. Even the cliché of English ethnicity (Lloyd's of London = England) is not free from a slippage into blackness, whereas Grant emerges from his black mask as untouchably tanned as ever. It is Grant's liberty to engage in insensate interracial intercourse without residue that triumphs in tandem with the commodification of a similarly interracialized Grace Kelly. This commodification of femininity triumphantly closes the film. All through *To Catch a Thief* she has refused to wear "real" jewelry, but in her final embrace with Grant she is wearing jewels even though the plot leaves it ambiguous whether they are real or Hollywood fakes. Or are they merely false like the necklace she wore earlier to seduce Grant in the film's famous "phallic symbol" set piece, which substitutes the visual joke of fireworks for a sexuality irretrievably displaced into tropes. Her shimmering gold dress in her "closing embrace" (to re-cite Morris) with Grant removes, however, any doubt that she is anything more than a fleshless embodiment of money, status and power *and* of something else altogether: an inaccessible interracial *jouissance*.

The fantasy copulation between the dark man in the Gray Flannel Suit and the superblonde is not accessible to the viewer except as a "commodity-image." This distance between the stars who focalize a displaced sexual anarchy associated with blackness and the normal fifties-era individual is stressed by Sloan Wilson's *The Man in the Gray Flannel Suit* (1955). The protagonist Tom Rath is stuck in a lower-middle-class lifestyle. He sets out for an interview at the "United Broadcasting Corporation," located in a Manhattan skyscraper, so that he can literally ascend the class elevator and become a professional manager like Grant at the beginning of *North by Northwest*:

The next morning Tom put on his best suit, a freshly cleaned and pressed gray flannel [...] There were eighteen elevators in the lobby of the United Broadcasting building. They were all brass colored and looked as though they were made of money. The receptionist in the personnel office was a breathtakingly beautiful girl with money-colored hair a sort of copper gold. "Yes?" she said.

"I want to apply for a position in the public-relations department." (7)

As Tom waits like any other exchangeable worker to enter this post-industrial world where such golden "money-colored" women will be his for the taking, he looks up at the consumable images that he might one day help produce, but will never embody—that is, at second-class versions of the Hollywood superrich:

On the walls were enormous colored photographs of the company's leading radio and television stars. They were all youthful, handsome, and unutterably rich-appearing, as they smiled down benignly on the job applicants. Tom picked a chair directly beneath a picture of a big-bosomed blonde (8).

Tom meets a mid-level functionary "also dressed in a gray flannel suit. The uniform of the day," and obtains a meeting with the organization man he hopes to embody: "Tom opened the door and saw a fat pale man sitting in a high-backed upholstered chair behind a kidney-shaped desk with nothing on it but a blotter and a pen. He was in his shirt sleeves, and he weighed about two hundred and fifty pounds. His face was white as a marshmallow" (8-9). Whiteness does not dazzle in the workaday world. No matter how "high" Tom gets in the corporate structure he will never attain this impossible position, which is no longer "white"

at this point but embodied in a contingent, mortal individual ("kidney-shaped") and "colored" like the multi-racial and multi-ethnic stars we have become familiar with ever since the color Hollywood films of the fifties. Grant, we recall, is introduced to us in *North by Northwest* descending the elevator that Tom wants to ascend. His gray suit is doubled by both the attendant and a lower-level functionary, and will be reiterated by African-Americans as the film progresses. It is significant that it is only in color that Grant began to appear less white than he did in black and white, a contingency that contributes to the hybridization of his star identity.

Grant loses his superwhiteness in *North by Northwest* only to regain it at the end of the film, yet we have seen how this conclusion leaves sex behind, or, rather, lets it be absorbed by his previous film. Whiteness finds itself appropriated by the black mask of interracial intercourse in *To Catch a Thief*. It is betrayed by a stain of *jouissance* irreversibly located in the locus of the other.[20] In the same year that *North by Northwest* appeared, *Night of the Quarter Moon* (dir. Hugo Haas, USA, 1959) engaged the taboo of interracial marriage, "an important link between the passing, 'tragic mulatta' films of the 1940s and 1950s," such as Douglas Sirk's *Imitation of Life* (USA, 1959), "and the interracial marriage as 'race problem' films of the 1960s," such as *One Potato, Two Potato* (dir. Larry Peerce, USA, 1964) and *Guess Who's Coming to Dinner* (dir. Stanley Kramer, USA, 1967; Ardizzone 91). 1967 was also the year in which the Supreme Court overturned state laws prohibiting interracial marriages in the Loving v. Virginia case, releasing biracial unions, crowds and children (and race anxieties above all) into the hinterland.

Where, if anywhere, can this impossible whiteness reassert itself as an inaccessible race-free abstraction? Where else but in the invisible position occupied by the high-angle shot, or the gaze of a hybrid British-American director whose entitlement as "Sir" continues to fool viewers into thinking he is English on the

disavowed basis of formal devices such as this signature shot. This disembodied ascription of power to the auteur hides his fat, mundane and marshmallow-white body from sight. If the high angle instances "the dominating look of the white male," or the "position of being without properties, unmarked, universal, just human," Hitchcock proves that whiteness "aspires to *dis*-embodiedness" (Dyer 38-9). This aspiration arises, as Hitchcock testifies, from a desire not to be degraded by association with either commodities or commodity-images, both of which are all too easily consumed and embodied by other races and ethnicities under High Capitalism.

The high angle traditionally encodes the powerlessness, impotence or ignorance of the characters caught in this shot. This lack of power is prefigured by a previously mentioned medium shot in the credit sequence where we see the director failing to hitch a ride on a racially abject, lower-class bus. If this medium shot undermines his own commodity image, it does so only to transfer the power that it wants to identify with the director's image to a higher perspective, or an imageless image only he can possess by perpetually aspiring to possess it: the signature high-angle shot. We see this high-Anglo shot many times in *North by Northwest*: in the library of the Long-Island mansion where Grant first learns from the *faux* Englishman Mason that he is to be killed; from the height of the UN building when we see Grant dwarfed by the cold abstract lines of the International Modernist Style as he flees a space where he has been framed for murder; toward the end of the film when we learn what Saint does not know, that she is to be thrown from the getaway plane or "disposed of," in the words of the English-accented Mason, "from a great height." So too, we see it when Grant receives a death threat in a hotel lobby in *To Catch a Thief*.

If Grant is "nothing" or disembodiment *par excellence*, this lack of ground is always slipping into its formally constitutive racial and ethnic otherness. Hitchcock's parodic embodiment of

Englishness in the form of his comical, "kidney-shaped" body evades, in contrast, this slippage by disembodying itself as a gaze occupying "a great height." This gaze loses "two hundred and fifty pounds" of embodiment ("Think Thin" is a motto invented by Grant's adman on the fly in *North by Northwest*) so as to abstractly embody the "murderous" Hitchcockian "power of the movie camera" that Cavell inherits from his reading of William Rothman's *The Murderous Gaze* ("North" 762). This high-angle position and its aesthetic pose of disinterestedness conspire to compensate for the threats posed by racial mobility and passing, yet Hitchcock cannot maintain this pose. The film ends in a tunnel, evoking a blackness or a sexual dimension that cannot be captured. *Jouissance*, Lacanians tell us, is "always missed" or misrecognized as what cannot be caught in language, like the bus at the beginning of the film and the even faster train at the end (Žižek, *Sublime* 69). Both buses and trains are, as we have seen, raced black in the film, speeding nowhere fast as they instantiate death, dearth and lack: White Panic.

Cary Grant, then, is black. Well, not quite. He is a star and so is free to be black, white, Jewish, "Arabic," Latin, Mediterranean, or any race, ethnicity and identity in between (McCann 15). This statement is not as shocking as it seems, since his conservative biographer writes that he is neither English nor American, but a "democratic symbol" (McCann 3), and what else does that mean but his having an aura that is more than merely white? The Statue of Liberty welcomes all races and ethnicities to America and it is from this "great height" that the white villain of *Saboteur* plummets to his death. McCann tries to explain away "Grant's alleged Jewishness" and the "olive skin" of his "*not* Jewish" / " Jewish mother" (13, 15-16), whereas Pauline Kael assumes that he is half-Jewish while also insisting that he is both "classless" and "stateless." McCann recycles, in turn, Kael's fetish-words— "classless" and "stateless" —with glee, as if they could incarnate the American class-contradiction of the "democratic gentleman"

without contradiction (92, 164, 298). If McCann and Kael go too far by suggesting that this mass of "contradictions" (McCann 3) is accessible to "everyone" (Kael), they do indicate the remote aura of an image whose inaccessibility is supplemented by a bisexuality similarly unavailable to the normative masses. Grant is able, when all is said and done, to fall away from white hetero-normativity because he is nothing more than star power person-ified:

"Even the greatest stars change themselves in the looking glass...."
Kraftwerk, "The Hall of Mirrors," Trans-Europe Express (1977)

Cruising Crusoe's (Internal) Colonialism:
His Girl Friday

I will conclude by offering support for this interpretation of Grant's inaccessible aura on the basis of the actor's manic comic performance in *His Girl Friday* (dir. Howard Hawks, USA, 1940). Grant and Rosalind Russell's characters are trying to save a man on death row for shooting a "colored policeman." *His Girl Friday* stresses what Hitchcock does not admit *and* denies: that biracial, visibly ethnic and African-American individuals had been part of the American police force for almost two centuries by the fifties (see Dulaney). Hitchcock's ahistorical resistance to having even one token racial or ethnic policeman armed with a gun that he might (according to racist paranoia) turn against his white superiors demonstrates that there are things that he cannot aestheticize and ironize through admittance and denial. This paranoia is legible today in the racist resentment simmering in America due to the fact that an African-American man is now occupying the highest position in the land and forcing white Americans "to confront that America no longer need[s] white Americans to reproduce its structures of power" (Pease 103).[21] Such a transgression is traumatic for it goes against the white desire to remain in the position of a benign, invisible and supervisory director vis-à-vis race mobility and social ascent. Hitchcock, we recall, insists that degenerate individuals like the Othello-figure Laughton or the black-blooded Fane throw themselves from any heights that they may achieve rather than pervert the abstract (read: white) locus of power by having external forces compel them to do so.

The Robinson Crusoe-esque title *His Girl Friday* encapsulates the colonial desire to remain dominant over women, non-whites,

natives, service people, slaves, animals and others of all kinds in a newly mobile world where "colored" soldiers were dying for America. The only reason a white man is on death row for murdering a "colored policeman" is, as Russell states without comment, because "the colored vote happens to be very important to the mayor of this town." Fear of a race war is doubled by a fear of democracy as what enables this racialized crowd to grow in power. The death-row case seduces Russell, who has divorced Grant and is about to marry Ralph Bellamy's character, into returning to work for Grant and results in their remarriage. A frenetic Russell initially resists remarrying Grant because she "wants to live like a human being". She wants, that is, to protect "the future of the race" (Allen, *Hitchcock's Romantic Irony* 77) by producing white children for the state once she "settles down [...] in Albany."

Whiteness is not, however, very stable in this whirligig of a film, where the fear that non-"Anglo-Saxon" immigrants are not seamlessly fitting into the fictional "*idea* of America" is pushed to the fore. This fear is legible when Louie (Abner Biberman), a man Grant keeps around to do his dirty work, is called a "dumb immigrant" who will "flop" or fail "on me" by his master. He and his "albino" girlfriend, a platinum-blonde working girl who Grant employs for blackmail jobs (no pun intended), foreground the difficulties in making even non-'colored' Americans white when Louie denies that his "albino" partner in crime is an Albanian: "Evangeline's no albino." To which Grant responds, "She'll do till one comes along" / Louie (indignantly): "She was born in this country" / Grant: "If she tries anything else, she'll have to stay in this country." Whiteness has almost nothing to do with pigment. If albinos parody the fiction of a literally white complexion into inanity, this parodic undermining of an imaginary center is also resisted by the film. It is resisted by presenting not-quite-whites as contained representations: immigrants, non-native born Americans or ethnic, non-'colored'

aliens (Albanians, Eastern Europeans, Jews, Muslims and other Balkanized and hybridized "race"-stereotypes), or as potential criminals threatened by rule of law, policing, imprisonment and capital punishment. Etymologies metonymed by "Albion," "Albany" and "albino" lend support, however, to a parodic instability of whiteness by signifying "to make white" (*albo*) and *albus: "white* (properly *dead white*, not shining [...] while *candidus* denotes a glistening, dazzling white)."[22]

Russell's character is dead set on denying the instability of whiteness in America by moving to and residing in Albany, the "State Capital" as well as the site of the "State Capitol" (i.e. a simulacrum of the national capital's Capitol building). She wants to dwell in Albany as if it were a screen image for New York City as the neo-imperial capital of a capitalist, post-industrialist and bio-political nation-state. Newsmen, she says, are "inhuman," whereas she wants to be more than a "newsgetting machine." She wants to be "just human" (to re-cite Dyer), or a white, middle-class child-begetter servicing the state. By the film's end, she and Grant decide to stay in the media game, remain inhuman and maintain their star power in the distant firmament.

They are stars, when all is said and done, news-producing machines crucial to the systems of power articulated by "governments, advertising, and the media" (Grant reportedly spied on his third wife-to-be for the FBI to "expedit[e]" his citizenship in 1942; Eliot 337). They may therefore marry whomever they like given that scandalous marriages increase the mind-numbing frenzy of the news media. Yet they may also divorce and remarry *ad nauseam* as if this freedom to consume holy matrimony as a commodity could solve the philosophical problems of the world. The exchangeability of commodified women and men in the marketplace is what ultimately voids the remarriage conclusion of *North by Northwest*. There can be no closure because remarriage in America is a repetitive representation endlessly deferring a reality spelled d-i-v-o-r-c-e. If divorce signifies how

human exchangeability and expendability constitute the bio-political horizon of capitalism, Hitchcock's aestheticization of sexuality, race, ethnicity and ever-growing crowds insists that American realities (not to mention the pre-cariously perverse matter perpetually misrecognized as Cary Grant... *absit nomen*!) will always exceed recuperation by his wily if ineffectual Romantic irony.

Race and militarized bio-politics remain, in the meantime, in cahoots. The recent *X-Men: Days of Future Past* (dir. Bryan Singer, USA, 2014) registers this traumatic tradition in American politics that most would prefer to look away from. "Luckily this building was built during segregation," says a tourist guide in the Pentagon in response to a child's cry for the bathroom. In other words, there are twice as many toilets in a post-segregationist era. The long duration of civilization depends, after all, on canalizing waste. Yet the 5000-year-old world system has had little need for race in the dismal nineteenth-century sense. Appeals to race are anachronistic yet are seemingly required for Americans and their non-decolonized doubles to look away from the history that this book has focalized through the male star of the forties and fifties. Today, one can be done with this history by: a) wanting to be done with it (post-racialism as a pure state of surveillance in which data trails trump pigmentation); b) not wanting to be done with it (race-blindness as what permits racism, profiling and academic-tokenism to continue functioning by insisting that it does not exist), and; c) warning that it is not over and done with (Bonilla-Silva and necessary radicals like *Race Traitor* Noel Ignatiev).[23]

In the meantime, re-territorializations on race permit bio-political expendability to continue operating under the all-purpose umbrella of a state of exception or emergency. Let us not forget that it is the ostentatiously titled "Professor," an agent of the United States Intelligence Agency, who speaks for this state of things. We hear this anonymous voice speak from on high in

response to Cary Grant's exasperated question, "Then why did you let the police chase me all over the map?" Why, in other words, didn't the Professor (he has no other name in the film) interfere with the police and suspend the rule of law that the police and legal system supposedly uphold in order to save his life? The other responds: "We never interfere with the police unless absolutely necessary. It has become necessary." The rule of law and order is wholly suspendable it seems but only for government ends and not to satisfy the narcissistic demands of human rights. Cary doesn't quite get it: "Then, I take it I'm to be cleared." The other: "I wish you'd walk faster, Mr. Thornhill. We'll miss the plane." One is never, then, "cleared" in this bio-political order of things. Ostensible acquittal and indefinite postponement are the only options available in a world where we depend on bio-politicized "means of locomotion" in order to access the highly ambivalent benefits of transnational trans-portation networks.

Notes

1. On the danger posed by ethnically and racially coded crowds, see Leslie Brill, "Canetti and Hitchcock: *Crowds and Power* and *North by Northwest*": "His movies are full of them, and they are frequently menacing" (128). "Yet," as Jonathan Cavallero recently notes, "representation of race and ethnicity in Hitchcock's work has been neglected" (3).

2. See Steven Cohan's "The Spy in the Gray Flannel Suit: Gender Performance and the Representation of Masculinity in *North by Northwest*" on how the Gray Flannel Suit instances a voiding of masculinity into performativity, or what fifties-era sociology called "other-directed" behavior (*The Lonely Crowd: A Study of the Changing American Character*; New Haven: Yale UP, 1950, David Reiman et al; cited in Cohan 55). Cohan identifies this performative, "other-directed" masculinity with "the new middle class, consumer-driven professional" aka the "conformist, personified by the organization man as a *consumer*" (Cohan 54; Cf. William H. Whyte's *The Organization Man*, New York: Simon and Schuster, 1958). Cohan curiously does not mention Sloan Wilson's novel as a source of "the man in the Gray Flannel Suit" alluded to by his title, a "catch phrase" that Wilson resented being associated with as late as 1983: "people often roared in high hilarity when they said to me, 'Are you the guy who wrote *The Man in the Gray Flannel Suit*?'" (Wilson 278).

3. This connotation of Grant as classiness incarnate is crucial to his star power, as the title of Graham McCann's academic biography attests. *Cary Grant: A Class Apart* confirms what conformists saw in Grant in the fifties by shying away from the by-now-commonplace view that the actor was bisexual or performatively ambiguous vis-à-vis sexual and, as we will see, racial and ethnic identities.

4. Debra Daniel-Richard suggests that Cary Grant's engagement for an evening at the Winter Garden Theater would have been to see *West Side Story*, which "opened at the Winter Garden Theater on 26 September 1957 and ran for 732 performances, closing in June 1959" (59).
5. See the diversified consensus expressed in relation to Grant's lack of ground by Spoto (302-3, 310-11), Eliot (485-6), Worland (8-9) and Rothman (*"North by Northwest"* 13).
6. There is also perhaps an inside joke on the fact that Cary Grant "jokingly referred to" his own dog "as his alter ego" and named it "Archie Leach" after his pre-Grant name Archibald Leach (Eliot 91).
7. See the *Oxford English Dictionary Online*, "grey, gray, adj." and "greyhound, n." Gray/grey connotes "the color intermediate between black and white, or composed of a mixture of black and white with little or no positive hue" while the etymological origin of the "grey" in "greyhound" "is unknown; it has no connection with GREY a. or with GREW a., Greek, nor with grey = badger."
8. The Cuban Missile Crisis, for example, "brought out a much harsher view of international politics" in *Topaz* (Walker 152).
9. DVD commentary to *North by Northwest* (2000).
10. Spoto misreads Laughton's celebration of a bygone "age of chivalry" in terms of a historically imprecise "Age of Elegance" (79), while Cohen associates Laughton's *envoi* with an adieu to the revolutionary "Enlightenment" (2. 34), which Burke's cult of "the age of chivalry" strenuously opposed as an "age of [...] sophisters, economists and calculators" (Burke 66). Cohen rightly dismisses revolutionary "romanticism" as a referent. Yet wouldn't it be apposite to say that Laughton embodies a conservative Romanticism akin to Hitchcock's "metaskepticism" or "romantic irony" (see Allen, "Metaskepticism" and *Hitchcock's Romantic Irony*) as well as to the "irony" that Carl Schmitt identifies as the

"reservation of all infinite possibilities" without "giving up any possibility," i.e. an adherence to the endless possibilities of consumption provided by a perpetually refining post-industrial prestige industry (Schmitt 72).

11. See Linklater's *Fast Food Nation* (2006) in regard to how human expendability has shifted to illegal and migrant labor in America. According to Wilson J. Warren, the working conditions of slaughterhouse laborers, whose lot was improved by legislation spurred in large part by Upton Sinclair's *The Jungle* (first published in 1905), have recently returned to the horrific levels exposed by Sinclair.

12. See Niels Werber, "Geo- and Biopolitics of Middle-earth": "The foe can be killed at will." He is "carrion" or "*Kadaver,*" yet "German troops" are also carcasses disciplined to display "'*Kadavergehorsam*': literally 'obedience of carrion'" (233); "the Nazi leadership saw their troops as living dead, or 'carrion'" (footnote 28).

13. Robin Wood recognizes the director's valorization of the state's "right of life and death" as one of the "fascist tendencies" (as opposed to Fascism "with a capital F") "in Hitchcock," a "contamination" that "runs very deep" and includes Hitchcockian aestheticization (37, 25-7).

14. In *La Carte Postale* (*The Post Card*), Derrida embeds Freud's pretension to "science" in a speculative philosophical project that can never conclude the "detour" of "metapho[r]" in the scientific direction that Freud ambivalently desired (348-9). Lacan embedded his own work in linguisteries over linguistics in order to stress the transference (roughly, mutual projections on the part of the analyst and the analysand) as an interminable process that can never be mastered by any pretense to "science," requiring, instead, a secular shamanism to pragmatically end analysis (see Borch-Jacobsen 57 and *passim*; in regard to Borsch-Jacobsen's employment of the term linguisteries, see 169-182).

15. See Rose on state fantasies, which are not a false consciousness, but a way of desiring and making sense of geo-political realities that presume the expendability of the individual (you or I) through our participation in what Mbembe analyzes as "the power of the fantasm and the fantasm of power" (212).

16. Allen reasserts that Fane is "primarily" a "refer[ence] to "sexuality" and not to "race" in *Hitchcock's Romantic Irony*, where a bio-political concern with "identifying, tracking down and neutralizing the threat posed to social propriety, procreative sexuality and the future of the race" apparently prevents any irony about race (101, 77). For a dramatization of Hitchcock's anxieties about the future of race and their present day ramifications, see Edelman (111-54).

17. "Yes, the bird war, the bird attack, the bird plague, you can call it what you want to, they're out there massing someplace and they'll be back, you can count on that!" as the male lead says to an ornithologist or 'fellow traveler' sympathetic to the birds. "It seems to be a pattern, doesn't it? They strike and disappear, and then they start massing again," he later tells his mate-to-be.

18. See White Studies pioneer Mike Hill on how "post-whiteness" in contemporary America means that "racial *integration*" in a homeland security state characterized by the "end of civil rights" has produced a situation where to be considered white is to have no rights vis-à-vis the state regardless of one's race or ethnicity: to be interrogatable and expendable in the name of national security (73). For a more race-insistent, realist and anti-post-racialist position, see Bonilla-Silva, "The Invisible Weight of Whiteness".

19. Mitsuhiro Yoshimoto, "Real Virtuality," in *Global/Local: Cultural Production and the Transnational Imaginary*. Eds. Rob Wilson and Wimal Dissanayake. Durham: Duke UP, 107-18 (cited in Cherniavsky 152). "[D]azzle" seems to be a mis-

citation of Richard Dyer's *White* (124), whereas Gilroy is previously cited in reference to the "damaging glare emanating from colonial conflicts at home and abroad"; see Paul Gilroy, *Against Race: Imagining Political Culture Beyond the Color Line.* Cambridge: Harvard UP, 2000 (cited in Cherniavsky xxi).

20. The "'other' wants to steal our enjoyment (by ruining our 'way of life') and/or it has access to some secret, perverse enjoyment" (Žižek, *Looking Awry* 165). In the case of whiteness, the normal viewer who wants to preserve the enjoyment of screen images for his or her own race insists that it remain "inaccessible to the other" (165). If, however, the "unutterably rich-appearing" commodity-image is also inaccessible to this viewer, as it is for the normal man Tom Rath (Wilson, *The Man in The Gray Flannel Suit* 8), then the prospect of the other attaining this screen space of obscene enjoyment can only "horrif[y]" the economically excluded white spectator (Žižek, *Looking Awry* 165); for example, the "rich-appearing" Sammy Davis Jr as a multi-racial screen star, or as a "one-eyed Negro Jew sneaking into a house in Beverly Hills," to cite a reiteration of fifties-era race anxiety in the recent retrofitted film *Hollywoodland* (dir. Alan Coulter, USA, 2006; Davis is also rumored to have "slept" with superblondes Marilyn Manson and Jane Mansfield).

21. "At the core of the Tea Party movement is a fantasy in which only the narrative of the white supervision of the black male can contain the trauma of its Real—the spectacle of a black man being in charge of himself and of the nation" (Pease 102-3).

22. See Charlton T. Lewis and Charles Short, *A Latin Dictionary*, "*albo*, v." and "*albus*, adj." Albion, a mythic reference underlying Anglo-Saxon supremacism slips away from whiteness by sliding into "Albanian," a term proliferating racial hybridity: "Of or pertaining to Scotland" as well as "Of or

pertaining to Albania" (see the *Oxford English Dictionary Online*, "Albanian adj.1 and n.1 / adj.2 and n.2"). See Clarke on how Anglo-Saxonism was "linked to ideas of white supremacy and racial purity," especially in relation to "immigration-restriction legislation" favoring emigrants from Britain and Northern Europe over Eastern Europeans (i.e. Albanians) in the early twentieth-century (86). In regard to Anglo-Saxonism as a way of admitting/denying conquest by Normans and Romans and of separating the English from debased Celtic Fringes (i.e. Wales, Scotland and Catholic Ireland) associated with Britons colonized by Rome, see Hingley (61-85). All this suggests that Anglo-Saxonism strives to make itself white in relation to the mixed raciality of Great Britain and America, hence the appeal to the mythic trope Al-bion, or to the bio-politics of an All-white life (*bios*) world; Cf. William Blake's insistence that "All things begin & end, in Albions Ancient Druid Rocky Shore" or "ancient Druid rocky shore" (*Jerusalem*, 46.15 and *Milton*, 6.25; in *Complete Poetry and Prose* 196, 100).

23. Bonilla-Silva reminds us, for instance, that "most marriages in America are still *intra*-racial" ("From bi-racial to tri-racial" 940; emphasis added); in regard to Ignatiev's views, see "The Point Is Not To Interpret Whiteness But To Abolish It."

References

Allen, Richard. *Hitchcock's Romantic Irony*. New York: Columbia UP, 2007.

— — — —. "Hitchcock and Cavell," *Journal of Aesthetics and Art Criticism* 64.1 (Winter 2006): 43-53.

— — — —. "Sir John and the Half-Caste: Identity and Representation in Hitchcock's *Murder!*," *Hitchcock Annual* 13 (2004-05): 92-126.

— — — —. "Hitchcock, or the Pleasures of Metaskepticism," *October* 89 (Summer 1999): 69-86.

Ardizzone, Heidi. "Catching Up with History: *Night of the Quarter Moon*, the Rhinelander Case, and Interracial Marriage in 1959," in *Mixed Race Hollywood*. Eds. Camilla Fojas and Mary Beltran. New York: New York UP, 2008. 87-112.

Bellour, Raymond. *The Analysis of Film*. 1979. Ed. Constance Penley. Bloomington: Indiana UP, 2001.

Blake, William. *The Complete Poetry and Prose of William Blake*. Ed. David V. Erdman. Rev. ed. Los Angeles: U of California P, 1982.

Bonilla-Silva, Eduardo. "The Invisible Weight of Whiteness: The Racial Grammar of Everyday Life in America," *Michigan Sociological Review* 26 (Fall 2012): 1-15.

— — — —. "From bi-racial to tri-racial: Towards a New System of Racial Stratification in the USA," *Ethnic and Racial Studies* 27.6 (November 2004): 931-50.

Borch-Jacobsen, Mikkel. *Lacan: The Absolute Master*. Stanford: Stanford UP, 1991.

Brill, Lesley. "Canetti and Hitchcock: *Crowds and Power* and *North by Northwest*," *Arizona Quarterly* 56.4 (Winter 2000): 119-46.

Burke, Edmund. *Reflections on the Revolution in France*. 1790. Ed. J.G.A. Pocock. Indianapolis: Hackett, 1987.

Byron, George Gordon. *The Complete Poetical Works*. Eds. Jerome

J. McGann and Barry Weller. 7 vols. Oxford: Oxford UP, 1980-93.

Canetti, Elias. *Crowds and Power*. 1960. Trans. Carol Stewart. Harmondsworth: Penguin, 1992.

Cavell, Stanley. *Pursuits of Happiness: The Hollywood Comedy of Remarriage*. Cambridge: Harvard UP, 1984.

— — — —. *Themes Out of School: Effects and Causes*. Chicago: U of Chicago P, 1988.

— — — —. "North by Northwest," *Critical Inquiry* 7.4 (Summer 1981): 761-76.

Cavallero, Jonathan J. "Hitchcock and Race: Is the Wrong Man a White Man?" *Journal of Film and Video*: 62.4 (Fall 2010): 3-14.

Chandler, James. *England in 1819: The Politics of Literary Culture and the Case of Romantic Historicism*. Chicago: U of Chicago P, 1998.

Cherniavsky, Eva. *Incorporations: Race, Nation, and the Body Politics of Capital*. Minneapolis: U of Minnesota P, 2006.

Clarke, Jennifer. "Anglophilia," in *Britain and the Americas: Culture, Politics and History Vol. 1: A-D*. Eds. Will Kaufman and Heidi Macpherson. 84-7. Santa Barbara: ABC-CLIO, 2005.

Cohan, Steven. "The Spy in the Gray Flannel Suit: Gender Performance and the Representation of Masculinity in *North by Northwest*," in *The Masculine Masquerade: Masculinity and Representation*. Eds. Andrew Perchuk and Helaine Posner. Cambridge: MIT P, 1995. 43-62.

Cohen, Tom. *Hitchcock's Cryptonymies: Volume 1: Secret Agents*. Minneapolis: U of Minnesota P, 2005.

— — — —. *Hitchcock's Cryptonymies: Volume II: War Machines*. Minneapolis: U of Minnesota P, 2005.

Corber, Robert J. *In the Name of National Security: Hitchcock, Homophobia, and the Political Construction of Gender in Postwar America*. Durham: Duke UP, 1993.

Daniel-Richard, Debra. "The Dance of Suspense: Sound and Silence in North by Northwest," *Journal of Film and Video* 62.3

(Fall 2010): 53-60.

Derrida, Jacques. *The Post Card: From Socrates to Freud and Beyond*. 1980. Trans. Alan Bass. Chicago: U of Chicago P, 1987.

Dulaney, W. Marvin. *Black Police in America*. Bloomington: Indiana UP, 1996.

Dyer, Richard. *White*. New York: Routledge, 1997.

Edelman, Lee. *No Future: Queer Theory and the Death Drive*. Durham: Duke UP, 2004.

Eliot, Marc. *Cary Grant: A Biography*. New York: Random House, 2004.

Hegel, G.W.F. *The Philosophy of World History*. Trans. John Sibree. New York: Dover, 1956.

Hill, Mike. "Whiteness as War by Other Means: Racial Complexity in an Age of Failed States," *Small Axe* 29.13.2 (June 2009): 72-89.

Hingley, Richard. *Roman Officers and English Gentlemen: The Imperial Origins of Roman Archaeology*. New York: Routledge, 2000.

Ignatiev, Noel. "The Point Is Not To Interpret Whiteness But To Abolish It" (talk given at the conference: *The Making and Unmaking of Whiteness*, Berkeley, California, April 11-13, 1997) http://racetraitor.org/abolishthepoint.html (accessed August 2013).

Jameson, Fredric. "Spatial Systems in *North by Northwest*," in *Everything You Always Wanted to Know about Lacan (But Were Afraid to Ask Hitchcock)*. Ed. Slavoj Žižek. New York: Verso, 1992. 47-72.

Jacobs, Steven. *The Wrong House: The Architecture of Alfred Hitchcock*. Rotterdam: 010 Publishers, 2007.

Kael, Pauline. "The Man from Dream City," *The New Yorker* (August 14, 1975) http://www.pbs.org/wnet/american-masters/episodes/cary-grant/the-man-from-dream-city/616/ (accessed July 2013).

Kashner, Sam. *The Bad and the Beautiful: Hollywood in the Fifties*.

New York: W.W. Norton, 2003.

Lacan, Jacques. *The Seminar: Book I, Freud's Papers on Technique.* 1975. Trans. John Forrester. New York: W.W. Norton, 1988.

Mbembe, Achille. *On the Postcolony.* Los Angeles. U of California P, 2001.

McCann, Graham. *Cary Grant: A Class Apart.* New York: Columbia UP, 1998.

McGilligan, Patrick. *Alfred Hitchcock: A Life in Darkness and Light.* New York: Regan Books/ HarperCollins, 2003.

Morris, Christopher D. "The Direction of *North by Northwest,*" *Cinema Journal* 36.4 (Summer 1997): 43-56.

Patterson, Charles. *Eternal Treblinka: Our Treatment of Animals and the Holocaust.* New York: Lantern Books, 2002.

Pease, Donald E. "States of Fantasy: Barack Obama versus the Tea Party Movement," *Boundary 2* 37 (Summer 2010): 89-105.

Rich, Norman. *Hitler's War Aims.* New York: W.W. Norton, 1992.

Rothman, William. *The Murderous Gaze.* Cambridge: Harvard UP, 1982.

— — — —. "*North by Northwest*: Hitchcock's Monument to the Hitchcock Film," *North Dakota Quarterly* 51 (1984): 11-23.

Rose, Jacqueline. *States of Fantasy.* New York: Oxford UP, 1998.

Schmitt, Carl. *Political Romanticism.* 1919/1925. Trans. Guy Oakes. Cambridge: MIT P, 1986.

Shakespeare, William. *The Arden Shakespeare Complete Works.* Eds. Richard Proudfoot, Ann Thompson and David Scott Kastan. New York: Arden, 1998.

Sinclair, Upton. *The Jungle.* 1905. New York: Viking, 1946.

Spoto, Donald. *Alfred Hitchcock: Fifty Years of His Motion Pictures.* 1976. New York: Anchor, 1992.

Walker, Michael. "*Topaz* and Cold War Politics," *Hitchcock Annual* 13 (2004-05): 127-53.

Warren, Wilson J. *Tied to the Great Packing Machine: The Midwest and Meatpacking.* Iowa City: U of Iowa P, 2007.

Werber, Niels. "Geo- and Biopolitics of Middle-earth: A German

Reading of Tolkien's *The Lord of the Rings*," *New Literary History* 36.2 (Spring 2005): 227-46.

Williams, Linda. *Hardcore: Power, Pleasure, and the "Frenzy of the Visible"*. 1989. 2nd ed. Berkeley: U of California P, 1999.

Wilson, George M. "The Maddest McGuffin: Some Notes on *North by Northwest*," *MLN* 94.5 (Dec. 1979): 1159-72.

Wilson, Sloan. *The Man in the Gray Flannel Suit*. 1955. Cambridge: Da Capo P, 2002.

Wood, Robin. "Hitchcock and Fascism," *Hitchcock Annual* 13 (2004-05): 25-63.

Worland, Rick. "Before and after the Fact: Writing and Reading Hitchcock's *Suspicion*," *Cinema Journal* 41.4 (Summer 2002): 3-26.

Žižek, Slavoj. *Looking Awry: An Introduction to Jacques Lacan through Popular Culture*. Cambridge: MIT P, 1992.

————. *The Sublime Object of Ideology*. London: Verso, 1989.

Contemporary culture has eliminated both the concept of the public and the figure of the intellectual. Former public spaces – both physical and cultural – are now either derelict or colonized by advertising. A cretinous anti-intellectualism presides, cheerled by expensively educated hacks in the pay of multinational corporations who reassure their bored readers that there is no need to rouse themselves from their interpassive stupor. The informal censorship internalized and propagated by the cultural workers of late capitalism generates a banal conformity that the propaganda chiefs of Stalinism could only ever have dreamt of imposing. Zer0 Books knows that another kind of discourse – intellectual without being academic, popular without being populist – is not only possible: it is already flourishing, in the regions beyond the striplit malls of so-called mass media and the neurotically bureaucratic halls of the academy. Zer0 is committed to the idea of publishing as a making public of the intellectual. It is convinced that in the unthinking, blandly consensual culture in which we live, critical and engaged theoretical reflection is more important than ever before.